Y0-CPC-759

MADISON COUNTY
LIBRARY
S Y S T E M

This book has been donated by

Sylvia and John Riley

in memory of

Butch Crawford

to the
Flora Public Library

590.222
BRO

CONSERVING
Wild.
America

Flora Public Library
Madison County Library System

Stoeger Publishing
Great Outdoor Books Since 1925

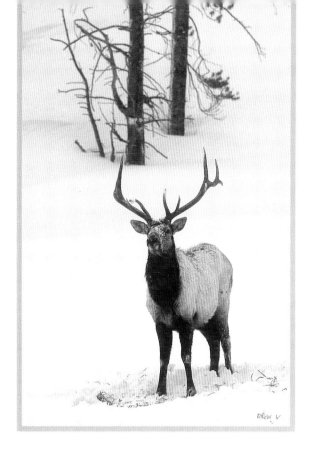

©Copyright 2002 by Stoeger Publishing Company.
All rights reserved. No part of this book may be reproduced
or transmitted in any form or by any means, electronic
or mechanical, including photocopying, recording,
or by any information storage and retrieval system,
without permission in writing from the Publisher.

Published by Stoeger Publishing Company
17603 Indian Head Highway, Suite 200
Accokeek, Maryland 20607

Library of Congress Catalog Card No: 2002110080

International Standard Book No: 0-88317-257-7

Printed in Korea

Distributed to the book trade and to the sporting
goods trade by
Stoeger Industries
17603 Indian Head Highway, Suite 200
Accokeek, Maryland 20607
Tel: 301-283-6300 Fax: 301-263-6986
www.stoegerindustries.com

Editor: Peggy W. Stegall
Graphic Design: Dennis J. Heckler
Publishing Assistant: Terry Mullen
All Photography, ©Copyright Paul T. Brown/trueexposures.com

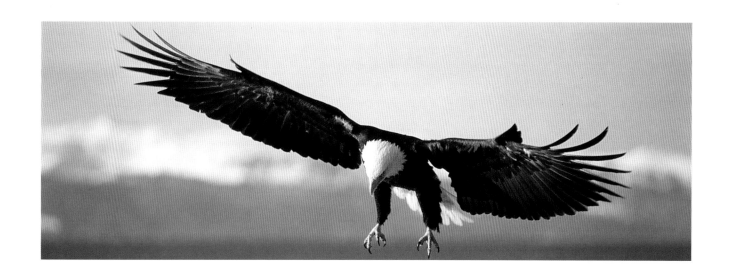

Table of Contents

Introduction

President Theodore Roosevelt, in his Chicago "Confession of Faith" address delivered August 6, 1912, left us with a prophetic message: "There can be no greater issue than that of conservation in this country."

Throughout his lifetime Roosevelt championed many conservation causes and made countless speeches on an issue that continues to be at the national forefront. We have benefited from his foresight and the awareness he generated on the critical need to protect, manage, and restore America's wildlife and wild places.

As you read about wildlife species in this book, you will realize we live in a generation of plenty. Go back in time to the turn of the 20th century, or even as recently as 40-50 years ago, and you will see the future of many wild species looked bleak. Some were even near extinction. Because of the tireless work and sacrifices of millions who volunteer their time and money to outstanding conservation organizations, Americans are enjoying exceptional opportunities in the outdoors.

This is not to say as a nation we have reached our conservation and restoration goals; far from it. We are faced with serious difficulties ahead. The natural resources of North America are not inexhaustible. It is our duty to continue our efforts and to support conservation groups. Future generations are dependent upon the work we do today.

As a wildlife photographer, my debt of gratitude to conservation groups is very personal. Without the accomplishments of these groups, I would have a difficult time practicing my craft. My work has been enhanced by the efforts of countless conservation organizations. In many instances, I could not have gotten the pictures without them.

For instance, I have photographed species, such as wild turkeys, in areas where they did not exist a few years ago. Even isolated places supporting struggling populations of certain species have benefited from national restoration and management programs. My heartfelt thanks goes to federal and state wildlife agencies and The National Wild Turkey Federation's volunteers and partners for the work they do.

Other organizations, including Quality Deer Management Association, have provided tools for whitetail deer managers that have multiplied my

opportunties to get shots of trophy bucks. The same accolades go to waterfowl groups such as Delta Waterfowl Foundation and Ducks Unlimited, for I have photographed countless waterfowl on impoundments created by their dollars.

In compiling this book I chose species that have a conservation or restoration story to tell. Many enjoy fascinating stories of success, while others face tougher challenges. Knowing it's impossible to feature every conservation organization battling for the protection of our wildlife, I have selected groups that represent individual species. There are certainly many other worthy organizations working hard to accomplish like goals.

This collection of photographs showcases my favorite big-game animals, ducks, turkeys, bald eagles, cats, and canines. These animals all hold a fascination of their own, and drive my passion for photography.

Each photograph occupies a special place in my heart. Each has created a special memory, and each strives to illustrate a species at its best in its natural habitat.

Every time I sit behind my camera I feel privileged. I can think of no other occupation that could bring me such satisfaction. Wildlife photography has truly blessed my life.

I invite bird watchers, hunters, hikers, anglers, and wildlife lovers all over America to extend appreciation and thanks to national agencies and private conservation organizations for the legacy they're helping to preserve. And I ask you all to join me as we celebrate the majesty and beauty of America's most treasured asset: our wildlife.

Paul T. Brown

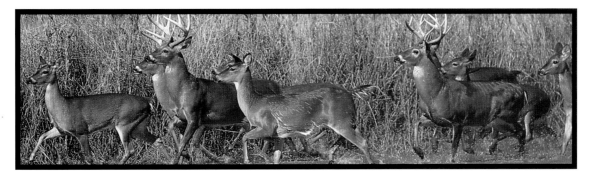

Whitetail Deer

Like most of North America's big-game populations, white-tailed deer were decimated during the 1800s due to unregulated market hunting and extensive habitat destruction. By the early 1900s, fewer than 500,000 whitetails remained from an estimated pre-settlement population of nearly 20 million. What followed is one of the greatest conservation success stories in wildlife management. Today, there are more than 30 million whitetails in the U.S., with many more in Canada, Mexico, and Central America. In fact, the whitetail deer is one of the most widely distributed, native big-game species in the world.

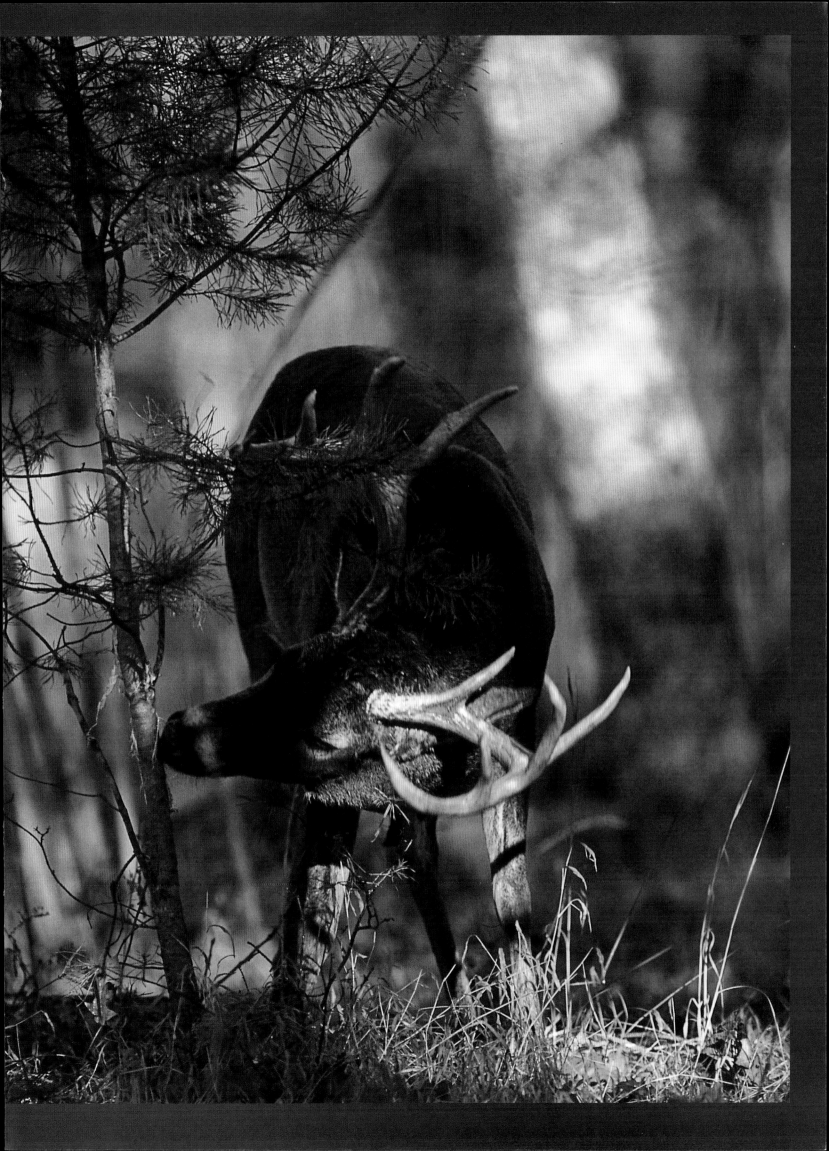

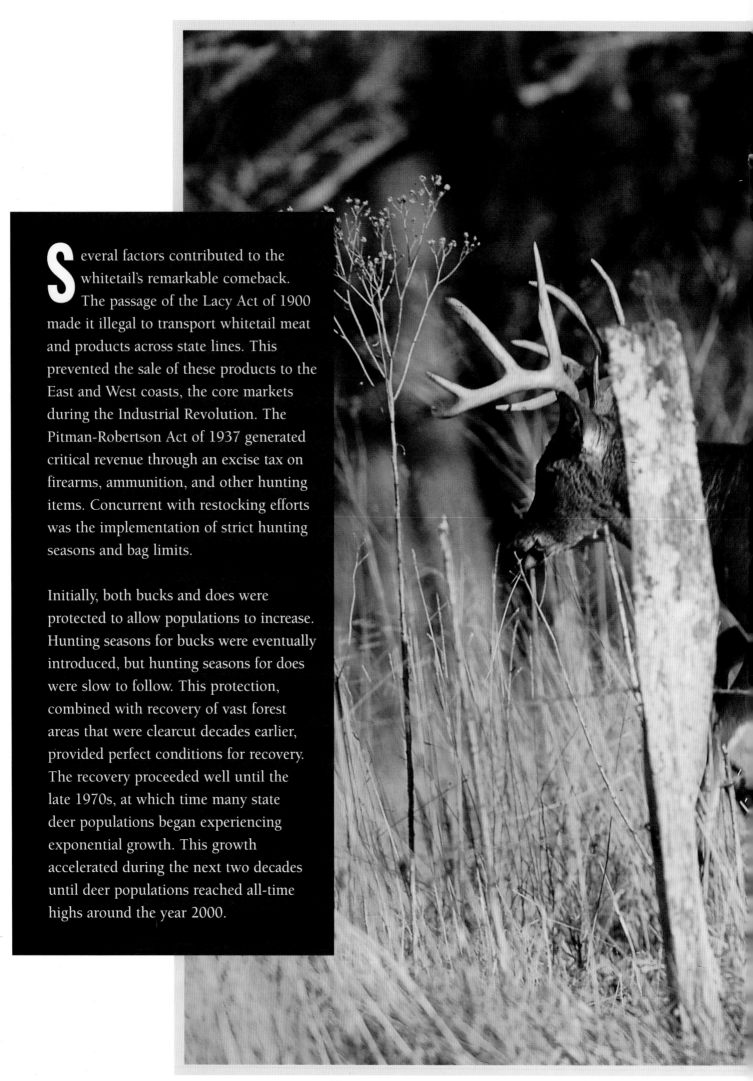

Several factors contributed to the whitetail's remarkable comeback. The passage of the Lacy Act of 1900 made it illegal to transport whitetail meat and products across state lines. This prevented the sale of these products to the East and West coasts, the core markets during the Industrial Revolution. The Pitman-Robertson Act of 1937 generated critical revenue through an excise tax on firearms, ammunition, and other hunting items. Concurrent with restocking efforts was the implementation of strict hunting seasons and bag limits.

Initially, both bucks and does were protected to allow populations to increase. Hunting seasons for bucks were eventually introduced, but hunting seasons for does were slow to follow. This protection, combined with recovery of vast forest areas that were clearcut decades earlier, provided perfect conditions for recovery. The recovery proceeded well until the late 1970s, at which time many state deer populations began experiencing exponential growth. This growth accelerated during the next two decades until deer populations reached all-time highs around the year 2000.

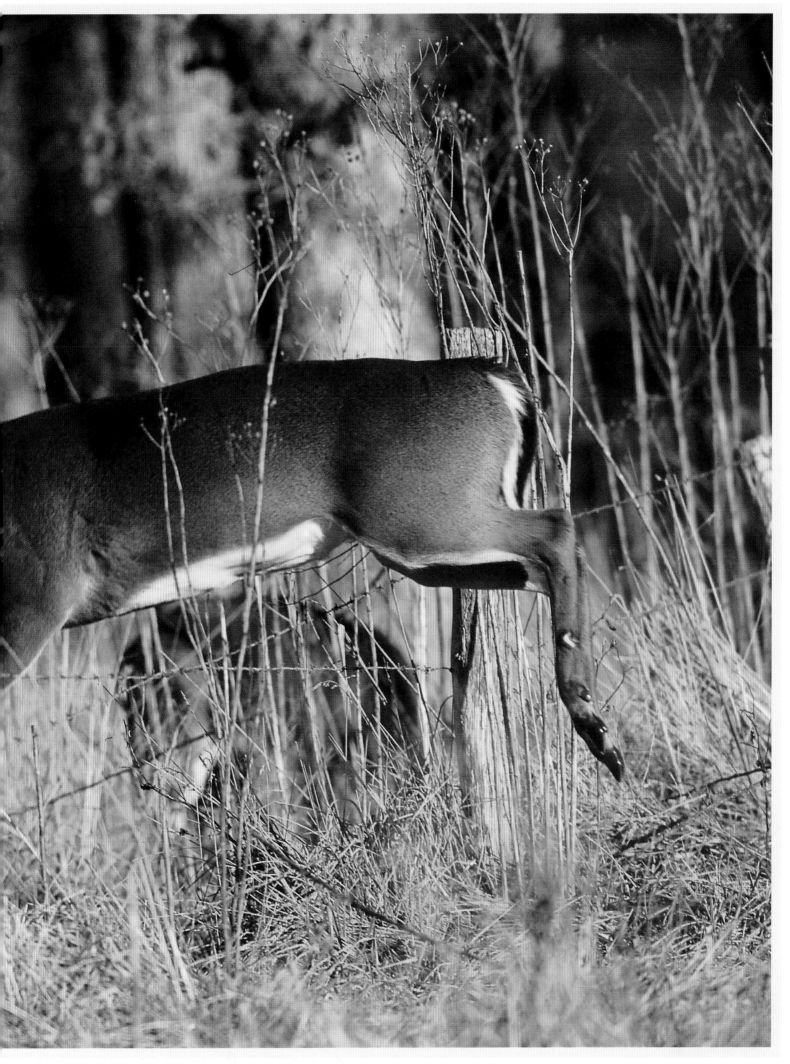

oday, whitetails are at or above carrying capacity in most areas. While high deer populations have provided abundant hunting opportunities for the nation's 11 million whitetails hunters, they have also resulted in numerous conflicts with society. Across much of the whitetail's range, increasing deer populations and decades of over-harvest of young bucks have resulted in large deer herds containing too many females and few mature males. Increasing deer/vehicle collisions and damage by deer to crops, timber, and the environment are also serious concerns. From these trends, it became obvious that a revolution in deer management was needed. This revolution came with the introduction of Quality Deer Management (QDM).

QDM is a management philosophy and practice that produces biologically and socially balanced deer herds within existing environmental, social and legal constraints. This approach typically involves the protection of young bucks combined with an adequate harvest of female deer to maintain a healthy population in balance with existing habitat conditions and landowner desires. A successful QDM program requires an increased knowledge of deer biology and active participation in management. This level of involvement extends the role of the hunter from consumer to manager and fosters a sense of pride and stewardship.

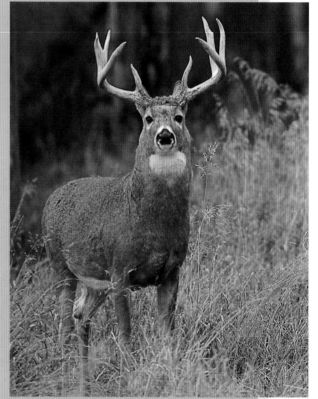

The Quality Deer Management Association (QDMA) is a national, nonprofit wildlife conservation organization and the leading advocate of the QDM philosophy. The organization's mission is to promote sustainable, high-quality whitetailed deer populations, wildlife habitats, and ethical hunting experiences through education, research and management. The QDMA was founded in 1988 by wildlife biologists and concerned sportsmen who recognized the need to control population growth and restore a more natural age structure and sex ratio to exploited herds. Over the past decade, both participation in QDM and membership in QDMA have increased rapidly. QDMA currently has approximately 20,000 members including more than 8,700 of the nation's leading deer management professionals. QDMA also is the only deer organization ever to receive the prestigious Group Achievement Award from The Wildlife Society, the parent body of more than 10,000 wildlife professionals.

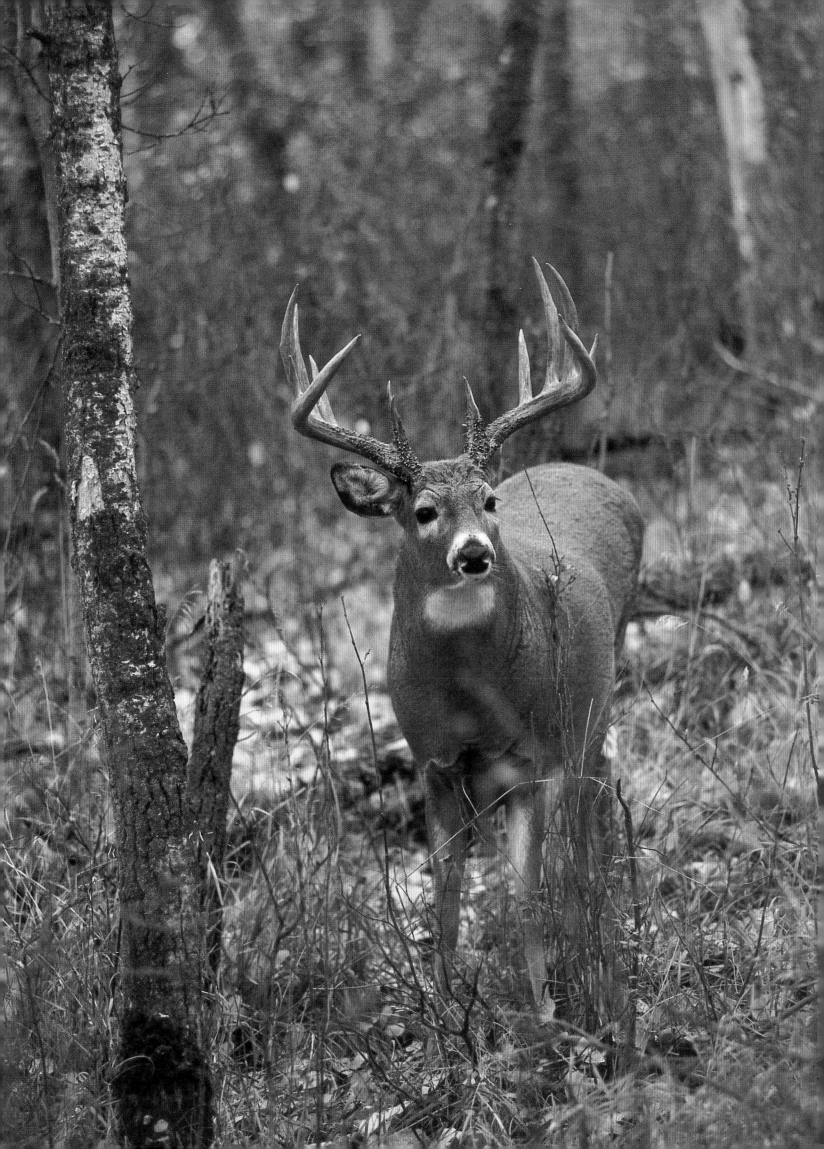

During its relatively short history, QDMA has made significant strides in the way whitetails are managed on both private and public lands. As of the year 2000, QDM practices have been implemented on more than ten million acres of private land and more than four million acres of public land in the country. In fact, based on recent surveys, approximately half of all deer hunters in the nation now support some form of QDM. This represents significant progress, but much work remains. Based on its achievements, QDMA appears well positioned to continue leading the efforts for a sustainable and high-quality future for whitetail management and hunting.

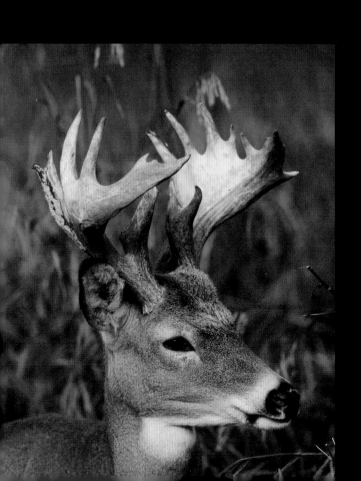

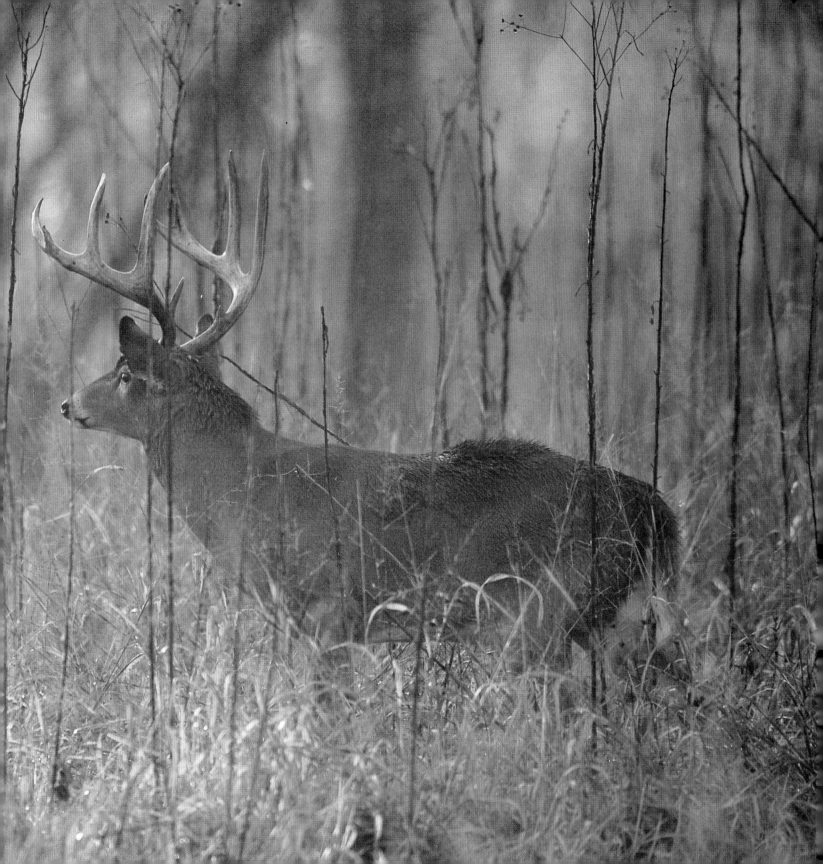

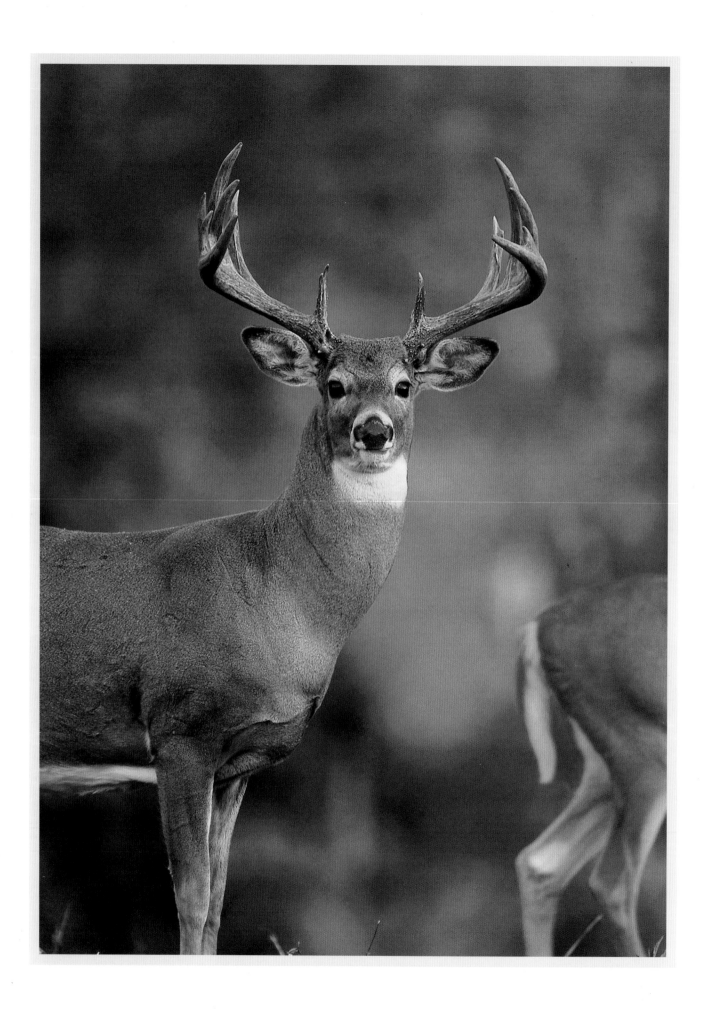

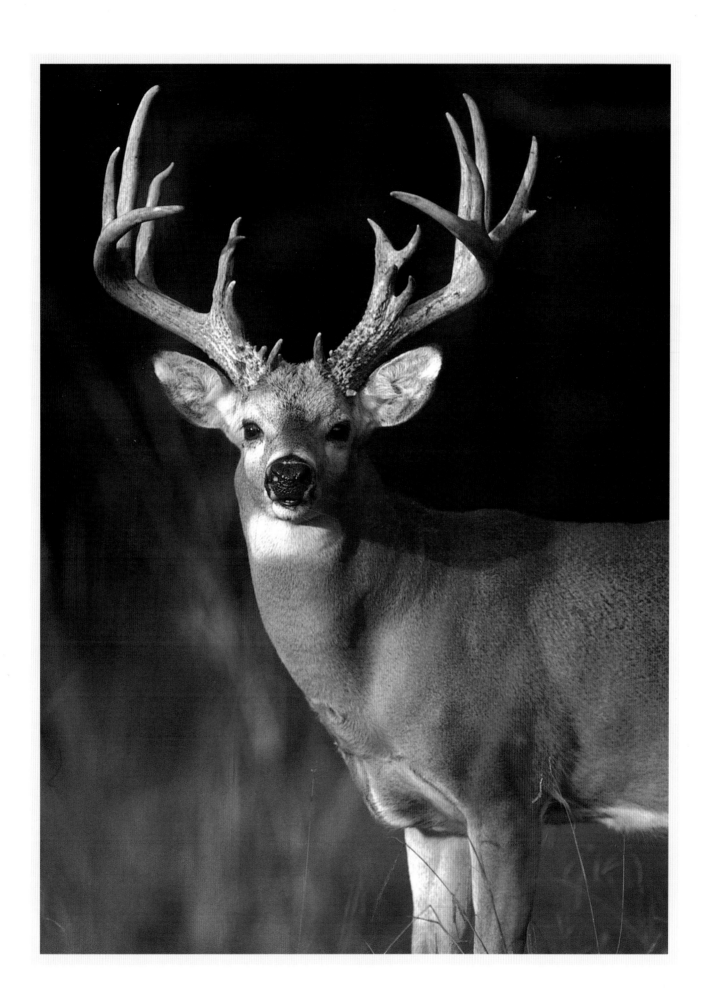

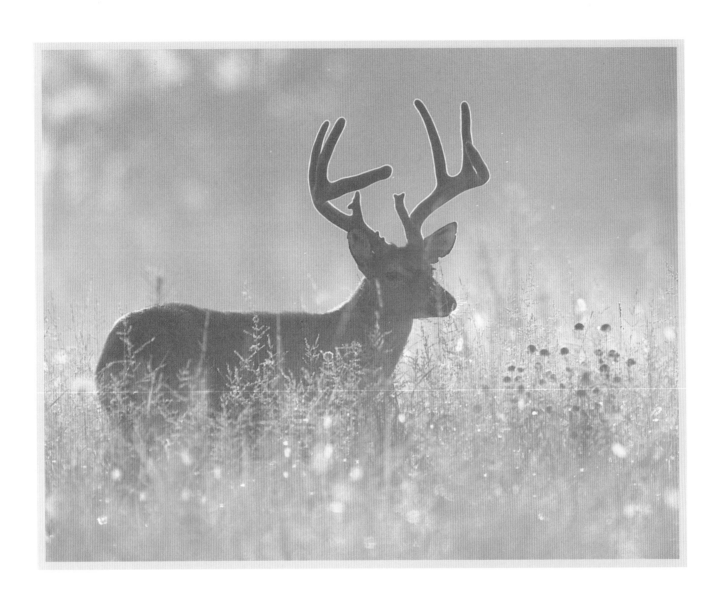

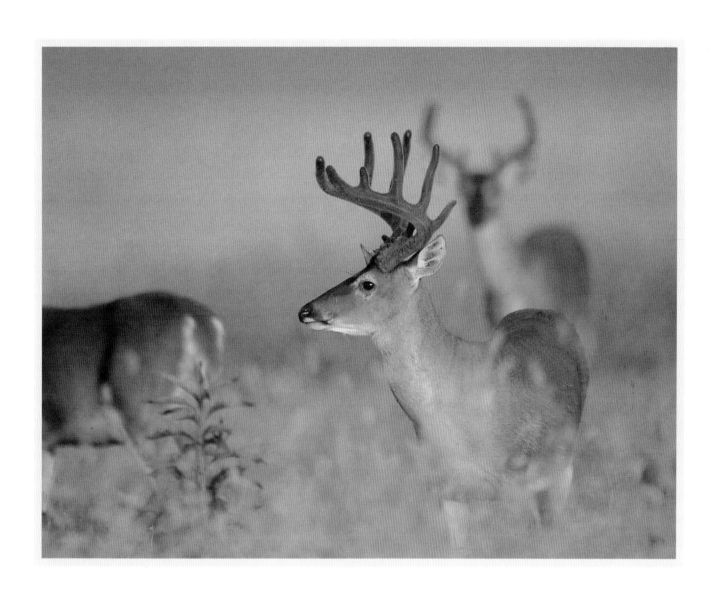

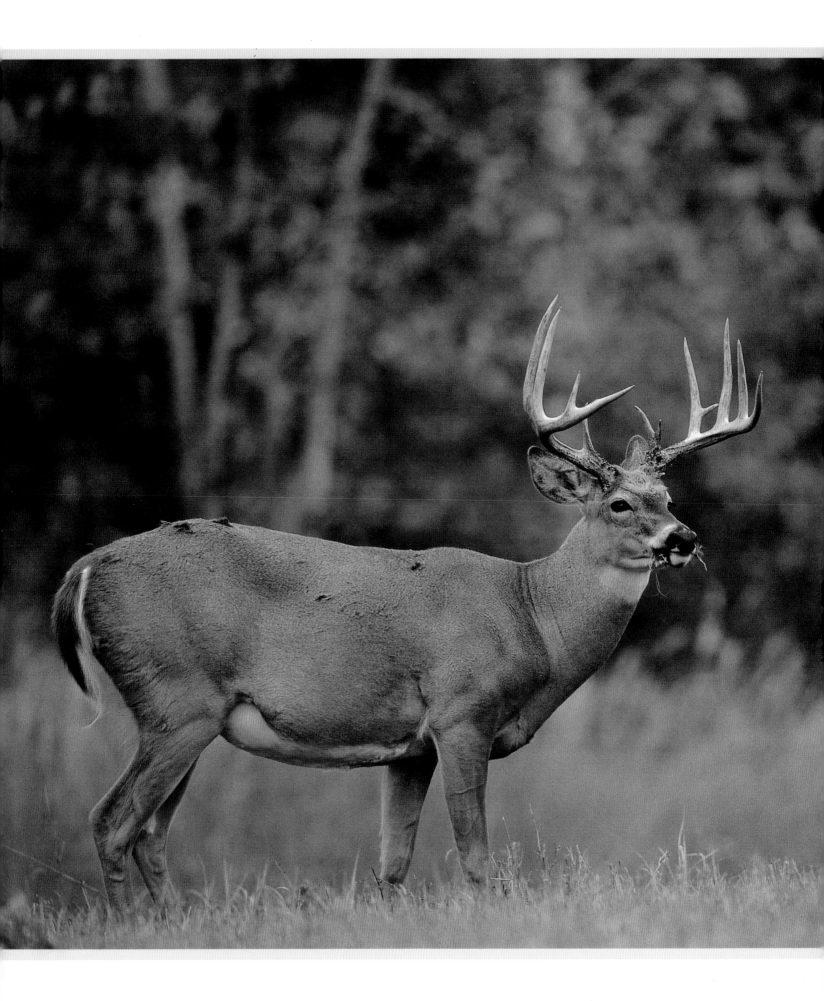

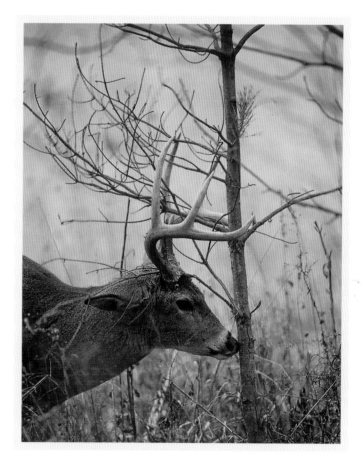

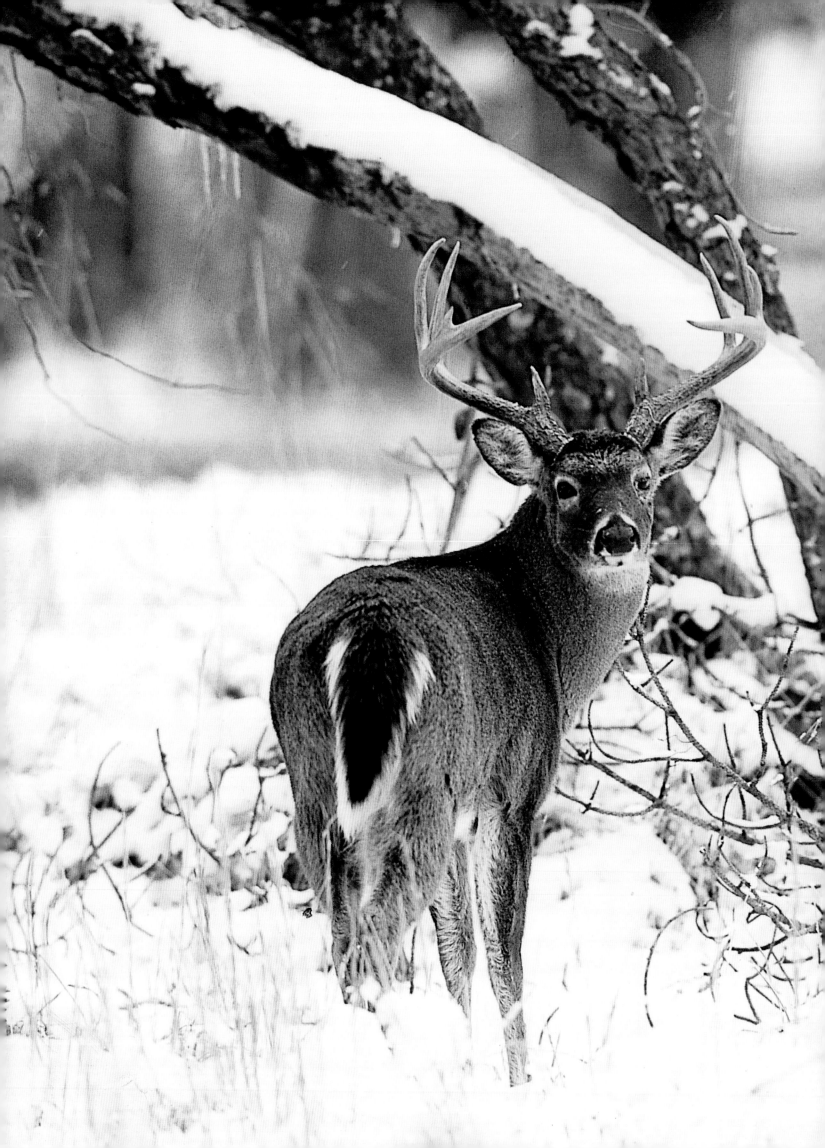

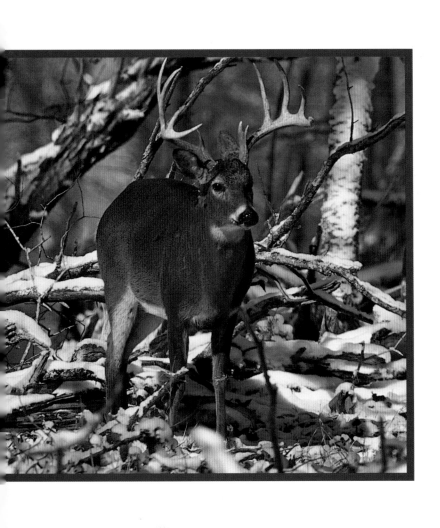

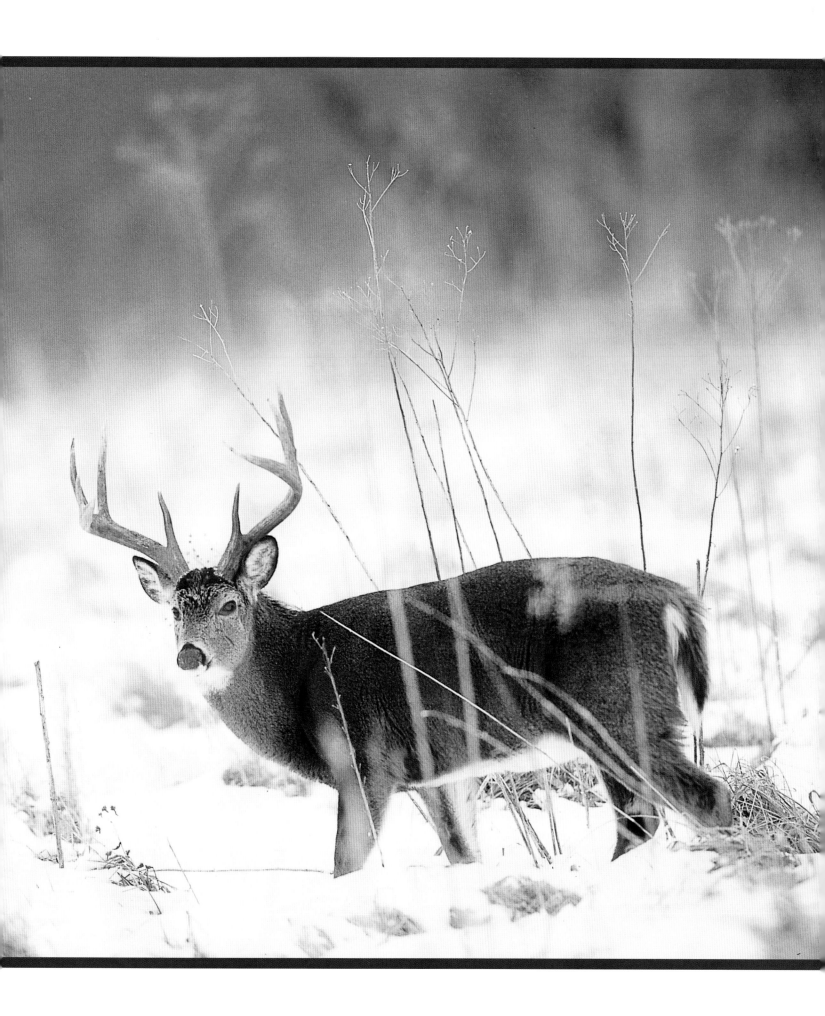

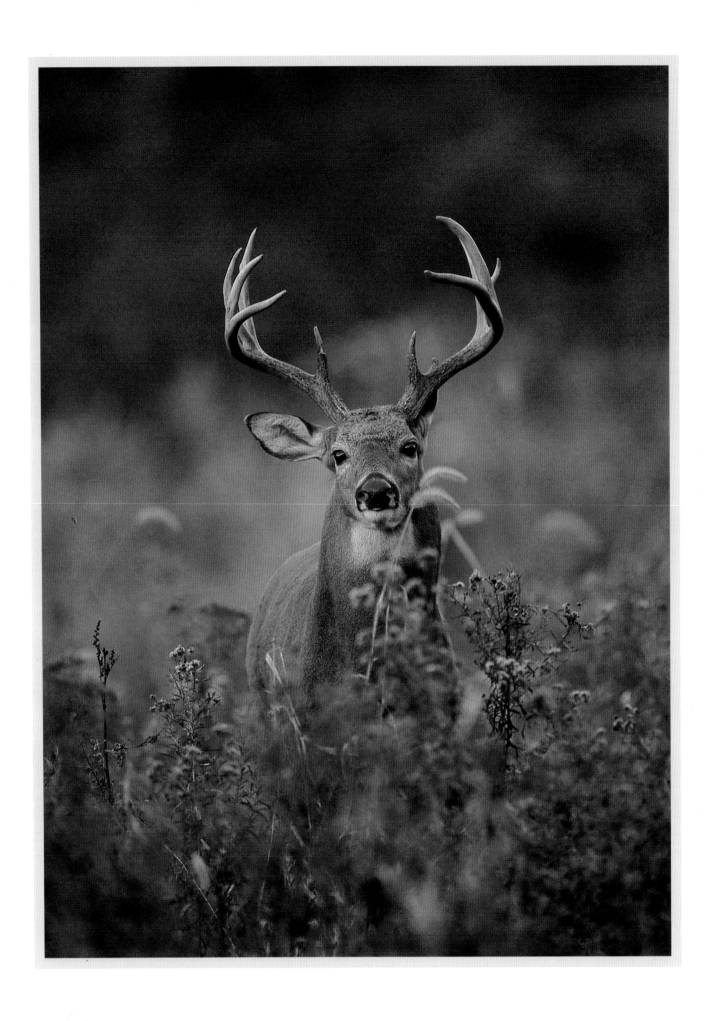

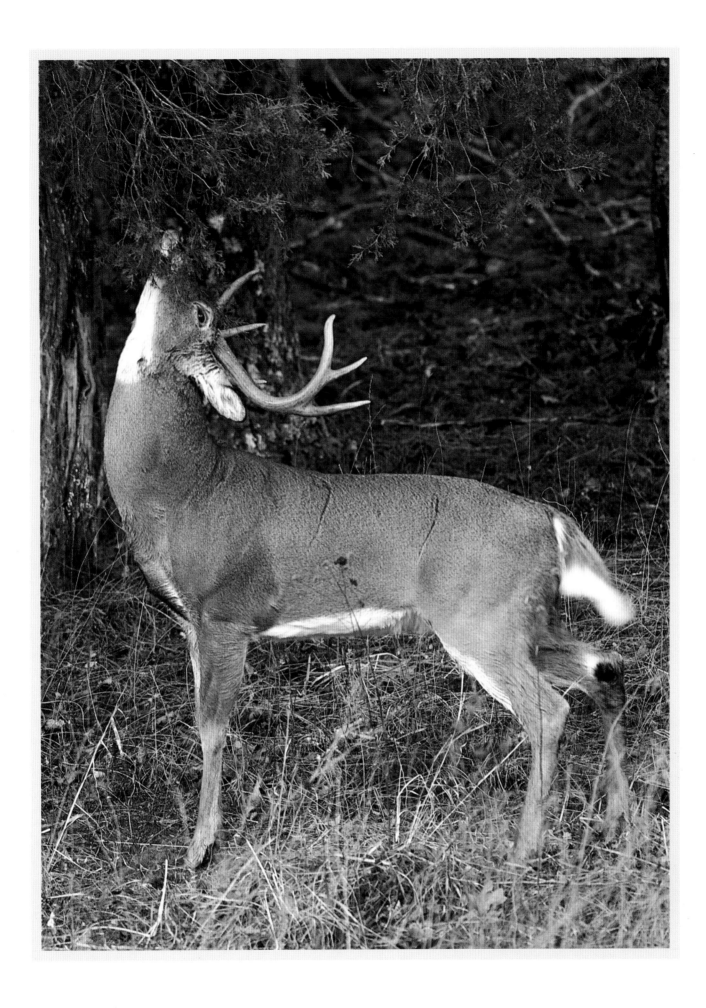

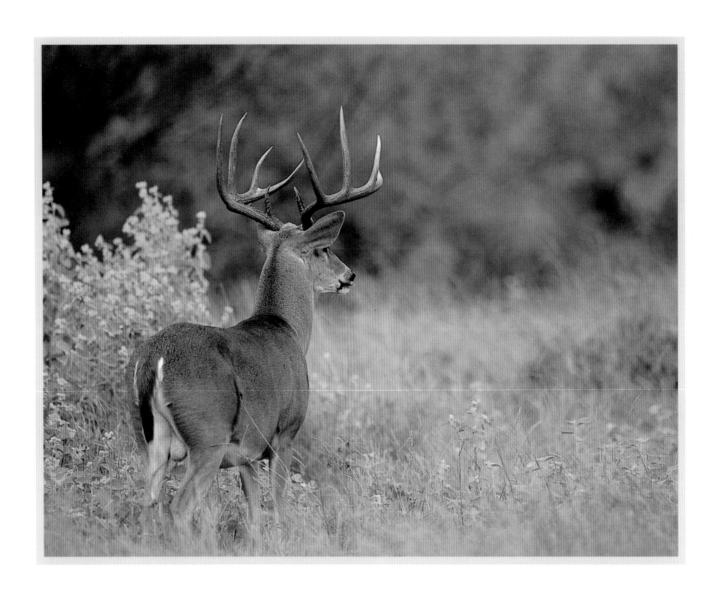

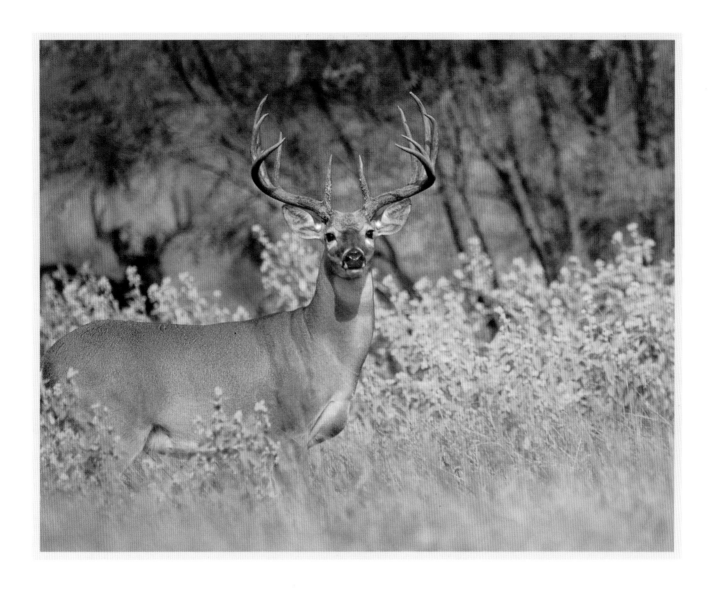

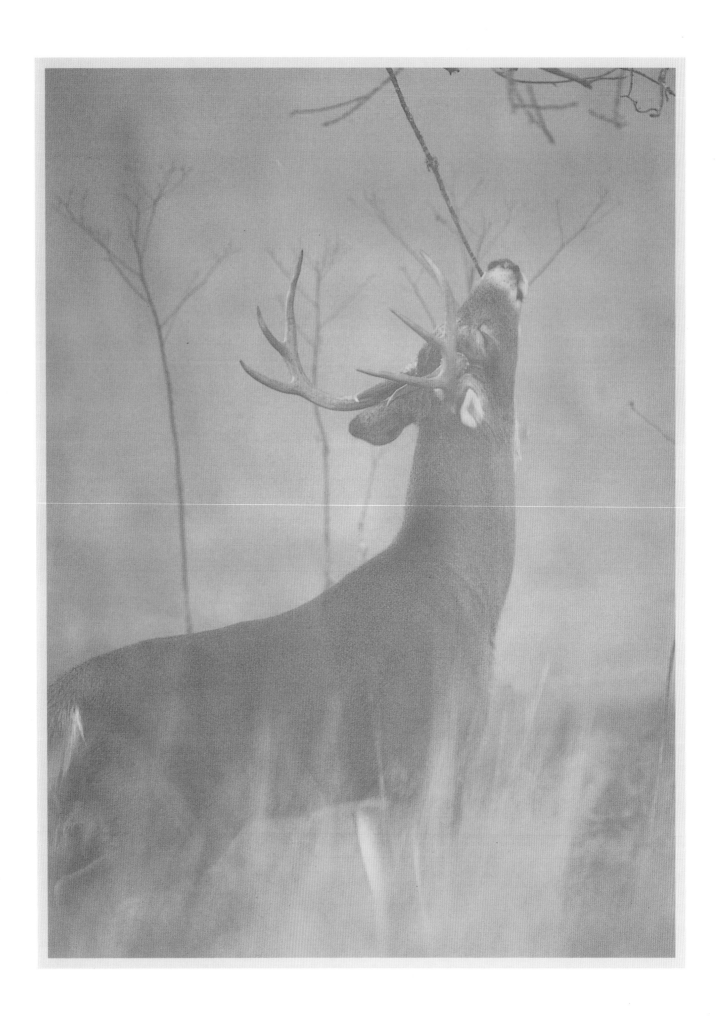

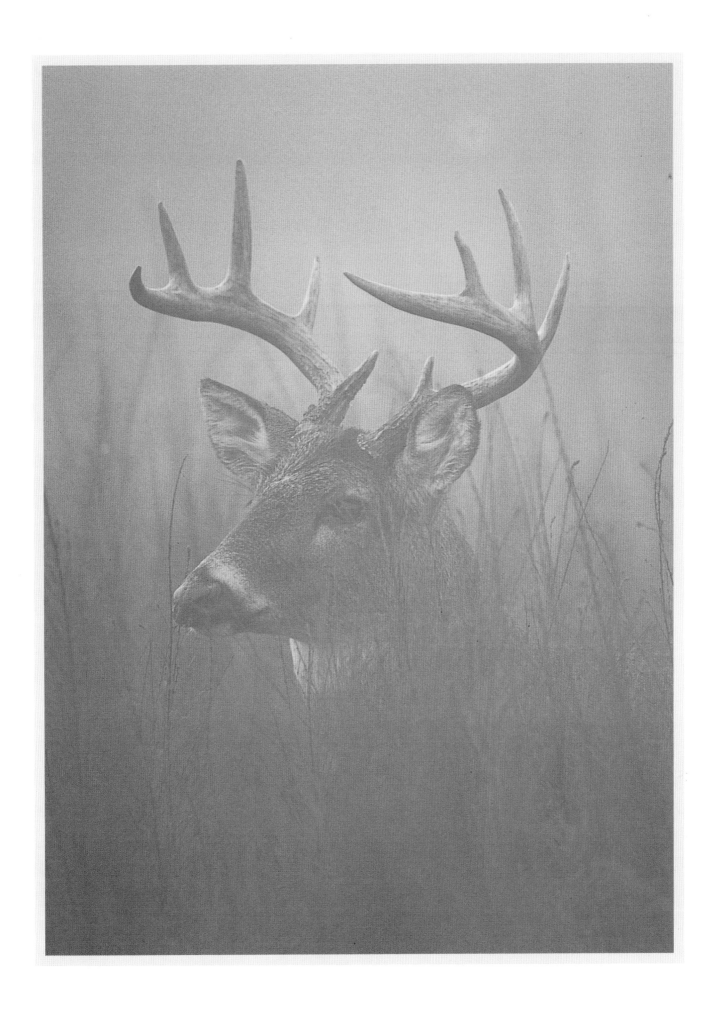

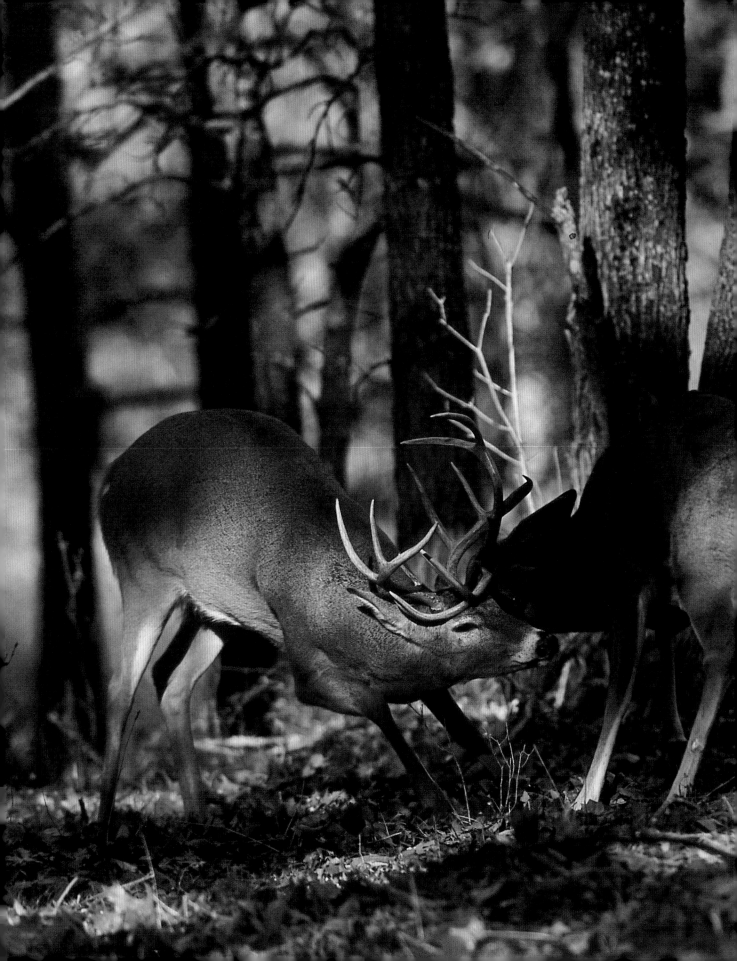

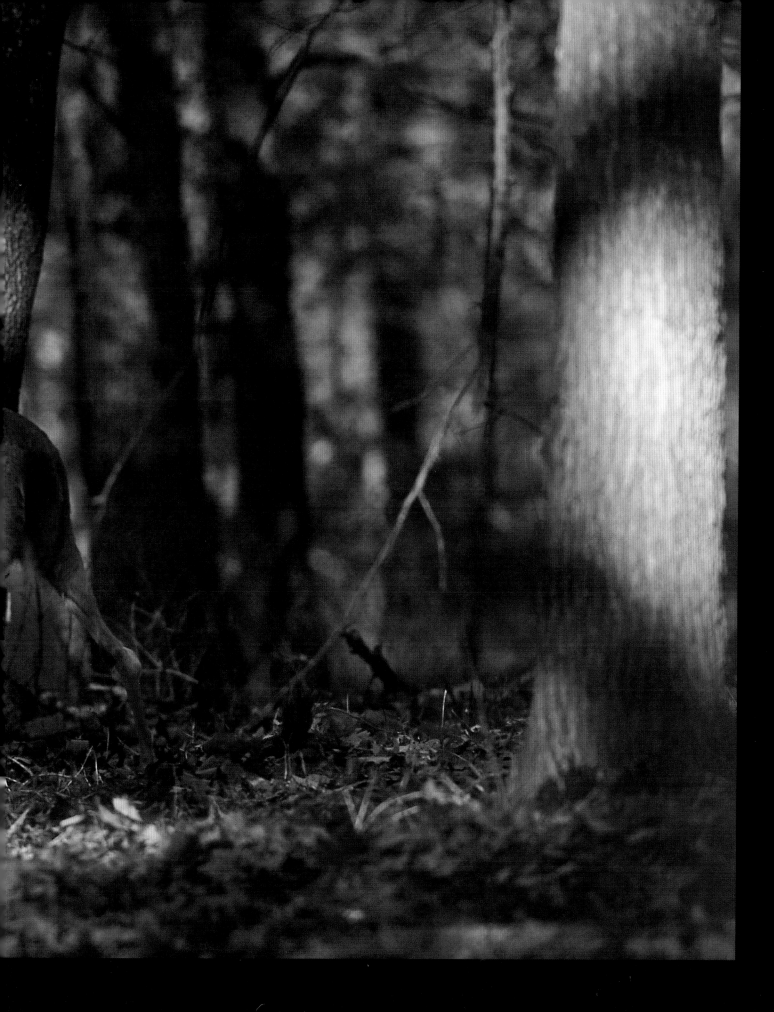

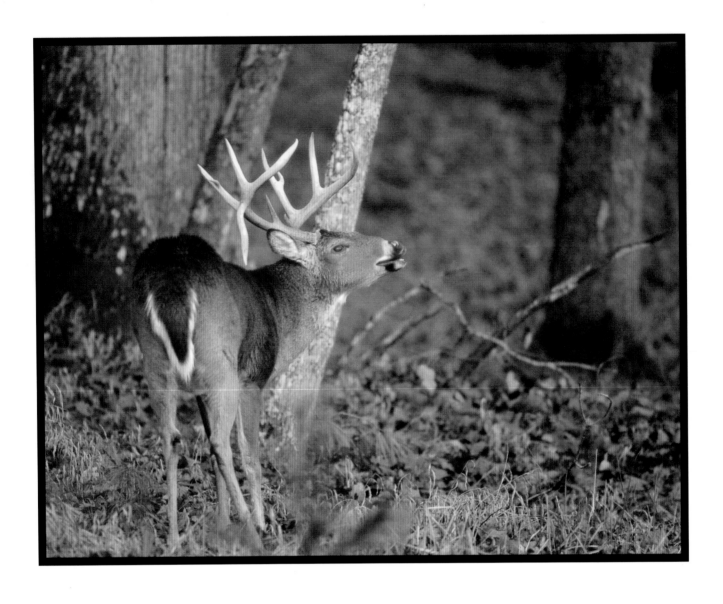

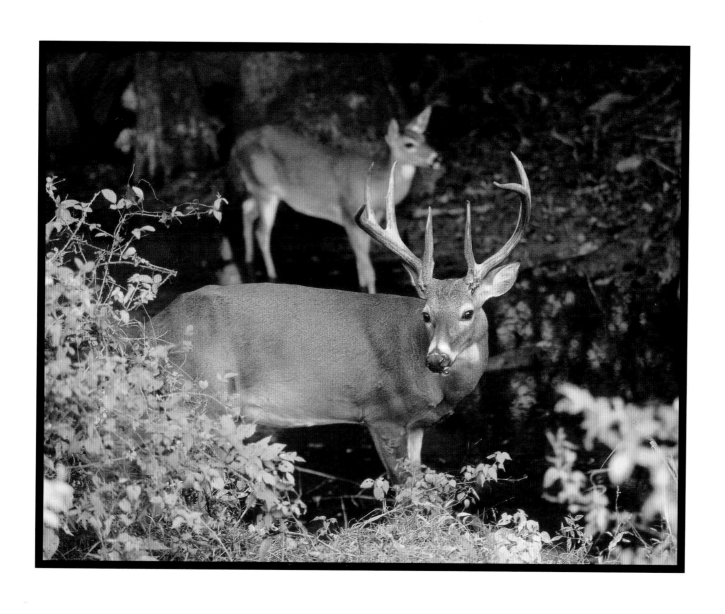

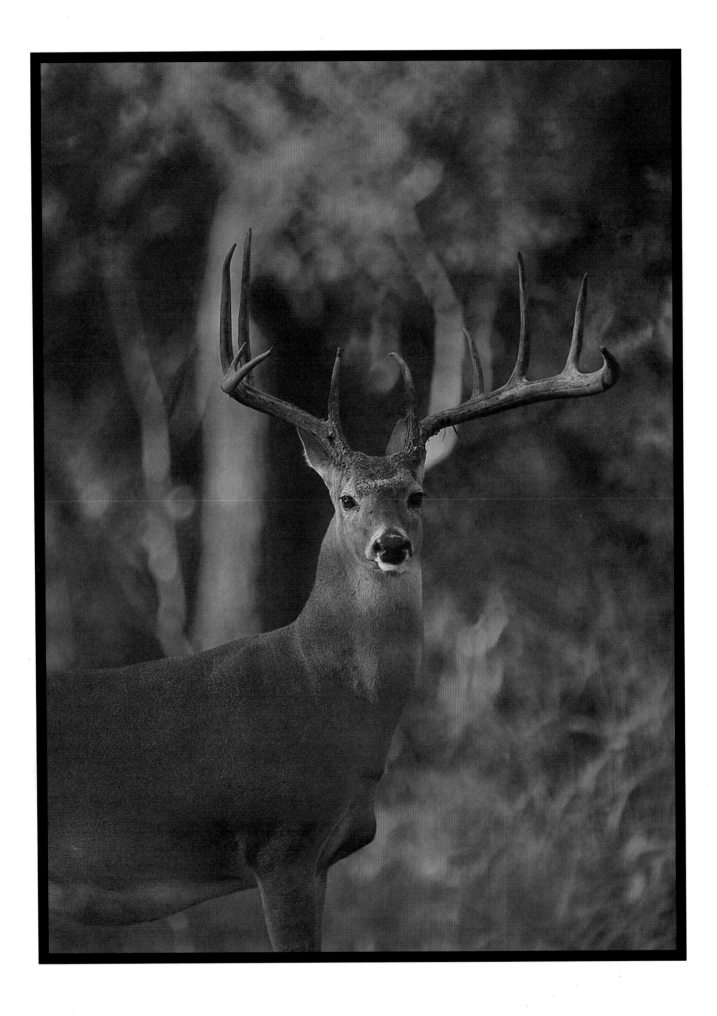

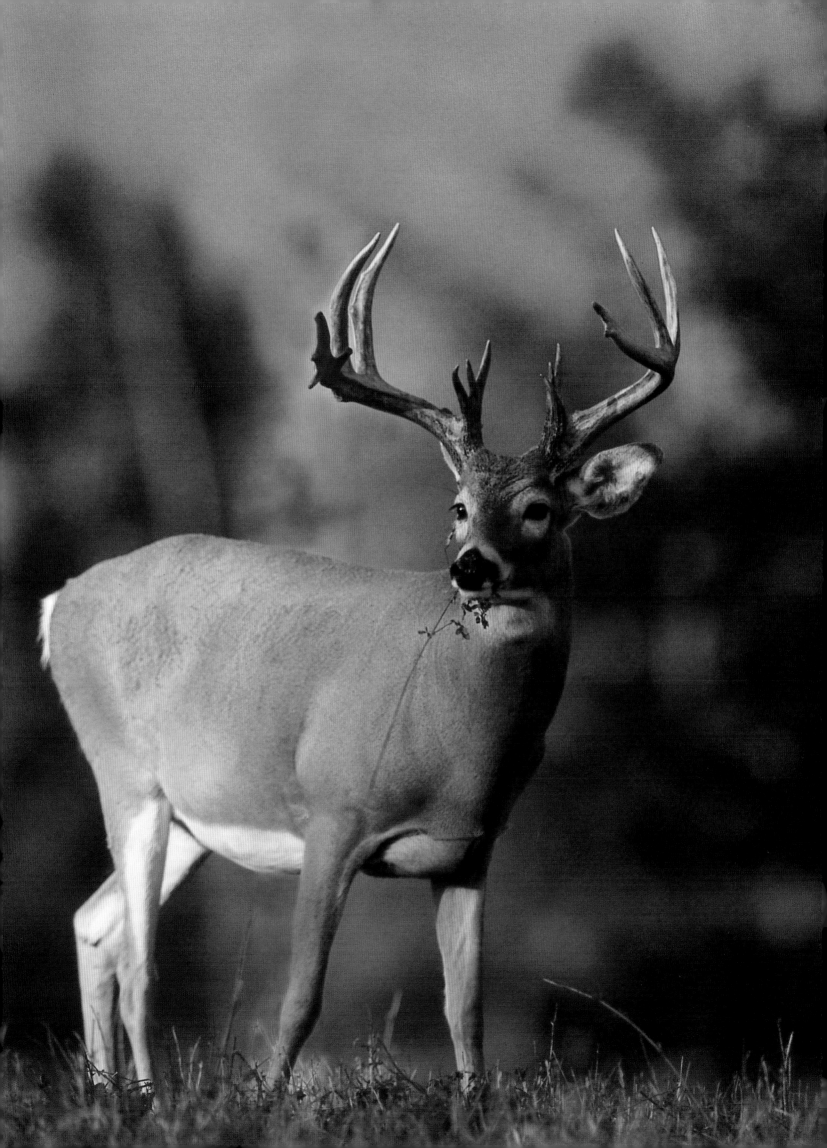

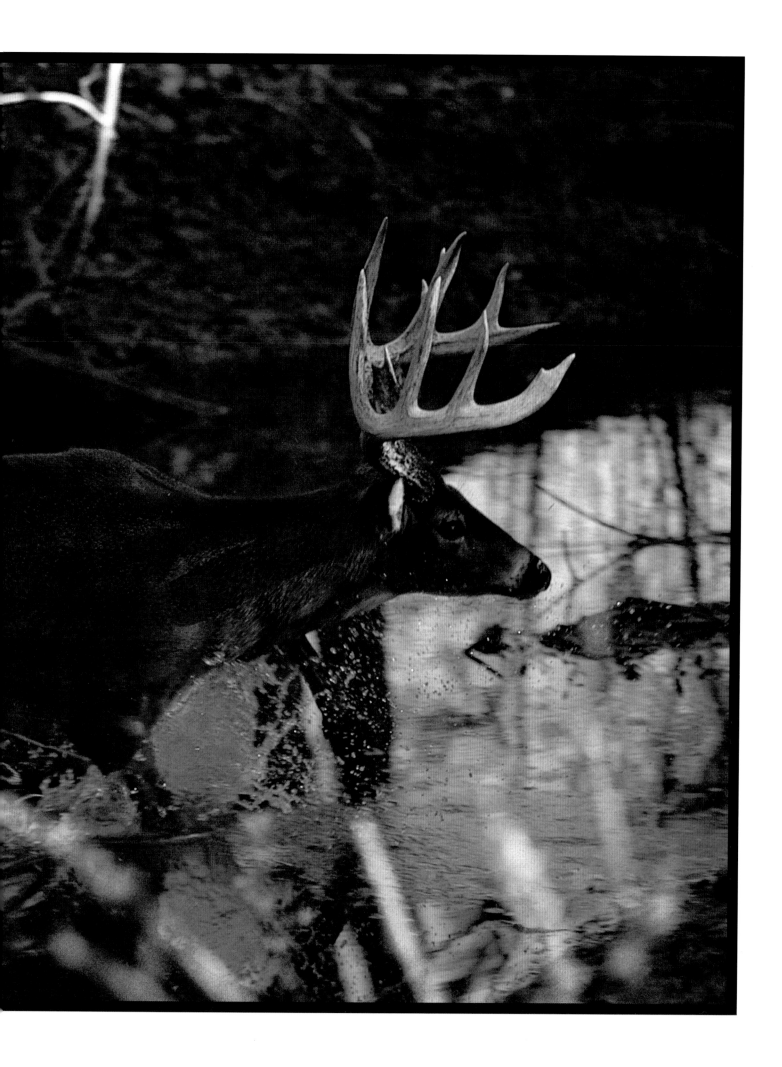

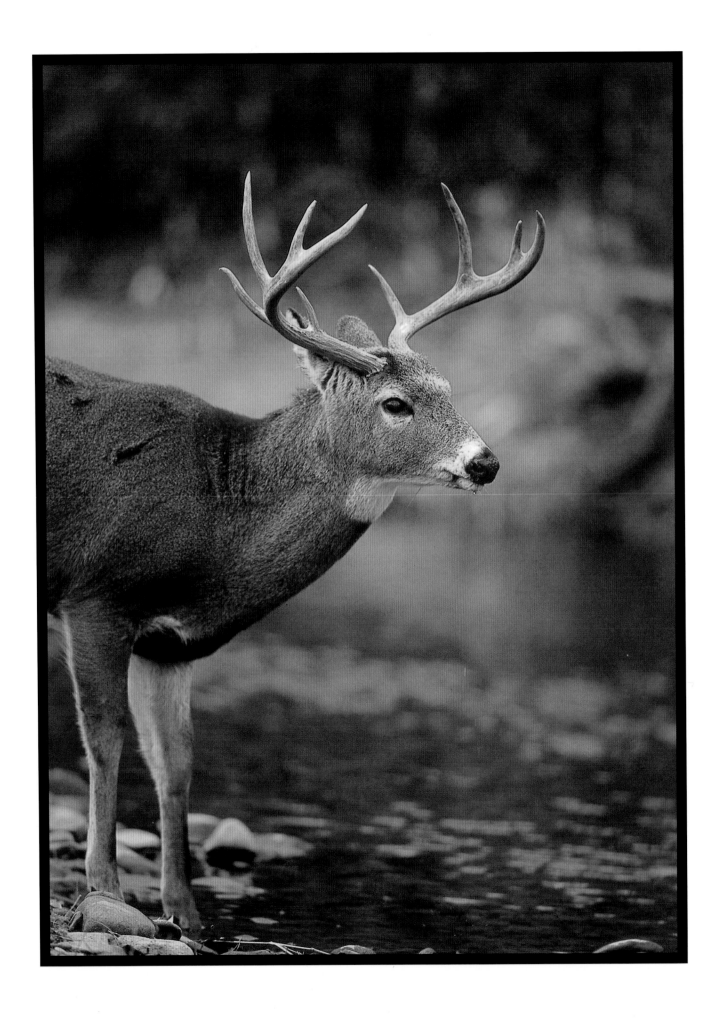

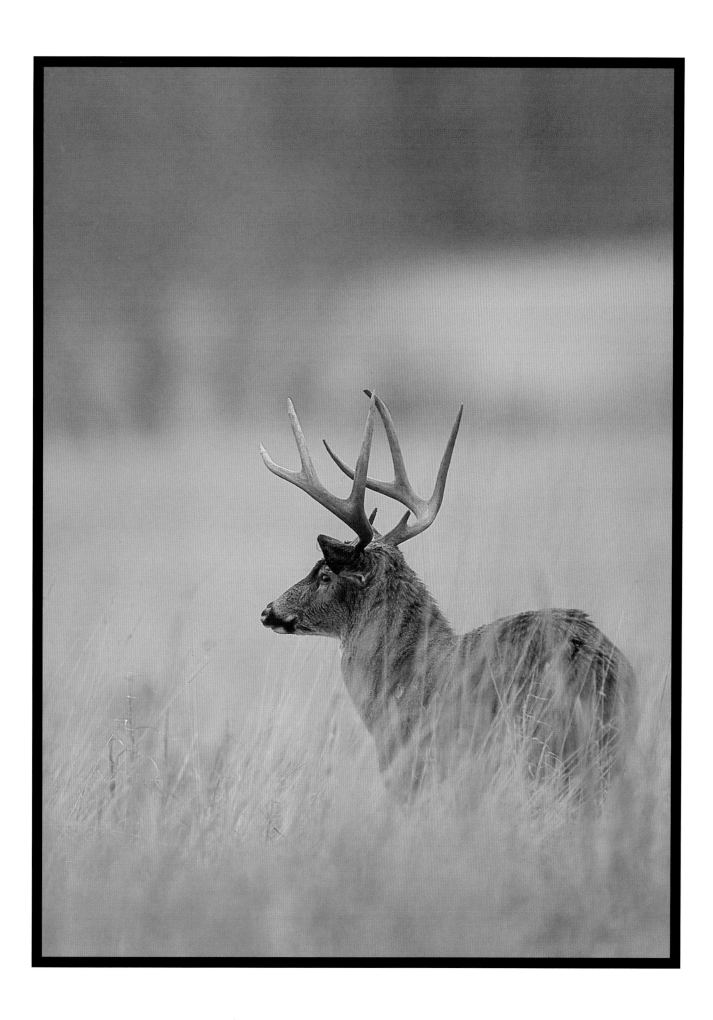

MULE DEER

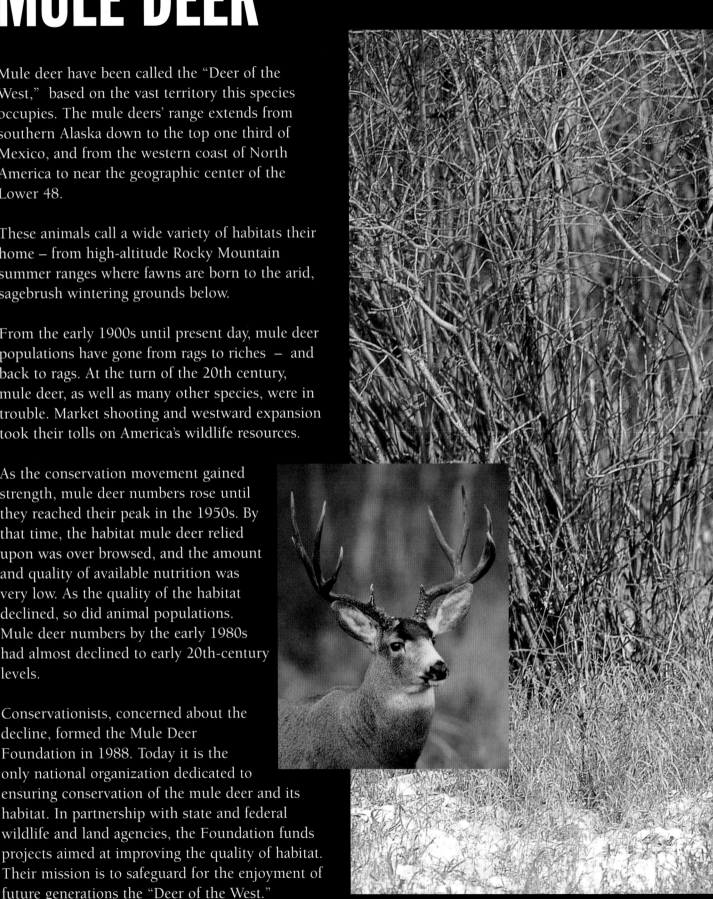

Mule deer have been called the "Deer of the West," based on the vast territory this species occupies. The mule deers' range extends from southern Alaska down to the top one third of Mexico, and from the western coast of North America to near the geographic center of the Lower 48.

These animals call a wide variety of habitats their home – from high-altitude Rocky Mountain summer ranges where fawns are born to the arid, sagebrush wintering grounds below.

From the early 1900s until present day, mule deer populations have gone from rags to riches – and back to rags. At the turn of the 20th century, mule deer, as well as many other species, were in trouble. Market shooting and westward expansion took their tolls on America's wildlife resources.

As the conservation movement gained strength, mule deer numbers rose until they reached their peak in the 1950s. By that time, the habitat mule deer relied upon was over browsed, and the amount and quality of available nutrition was very low. As the quality of the habitat declined, so did animal populations. Mule deer numbers by the early 1980s had almost declined to early 20th-century levels.

Conservationists, concerned about the decline, formed the Mule Deer Foundation in 1988. Today it is the only national organization dedicated to ensuring conservation of the mule deer and its habitat. In partnership with state and federal wildlife and land agencies, the Foundation funds projects aimed at improving the quality of habitat. Their mission is to safeguard for the enjoyment of future generations the "Deer of the West."

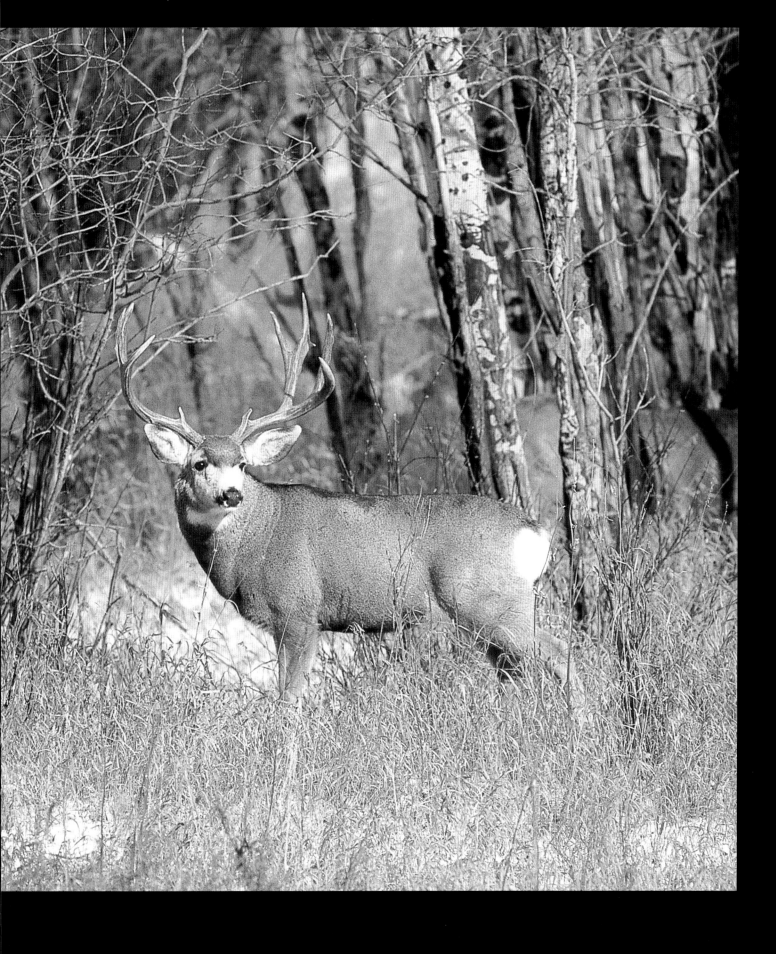

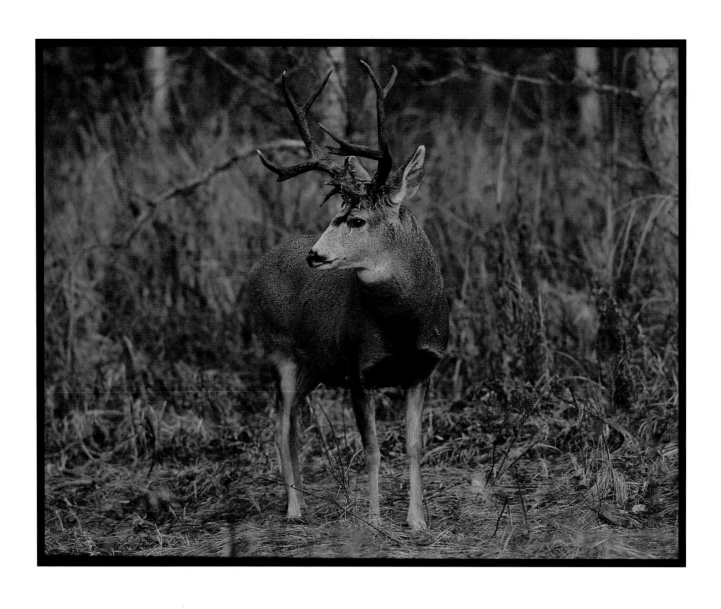

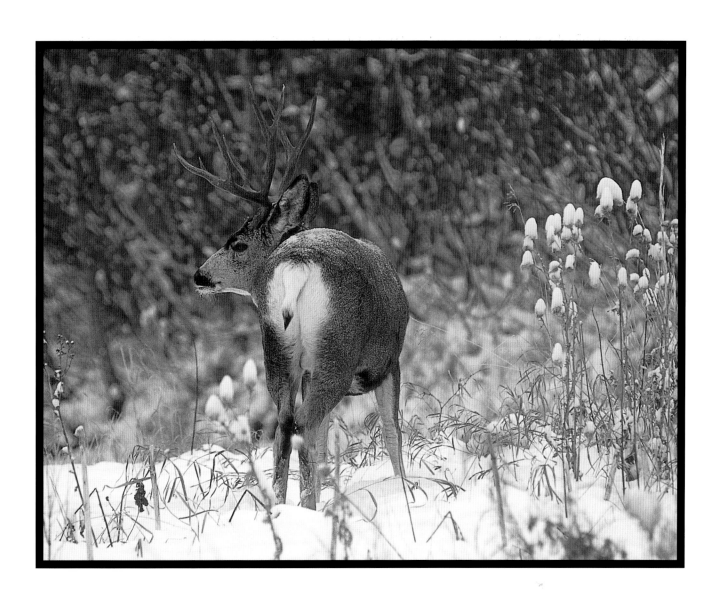

Waterfowl

In 1900, observers estimated there were approximately 120 million migratory waterfowl in North America. By 1935, those numbers had dropped to around 30 million. While these numbers are rough calculations, they indicate unequivocally a severe decline. This catastrophe was believed to be the result of human induced changes on the landscape, as well as a series of persistent prairie droughts that likened the continent to "a giant dust bowl."

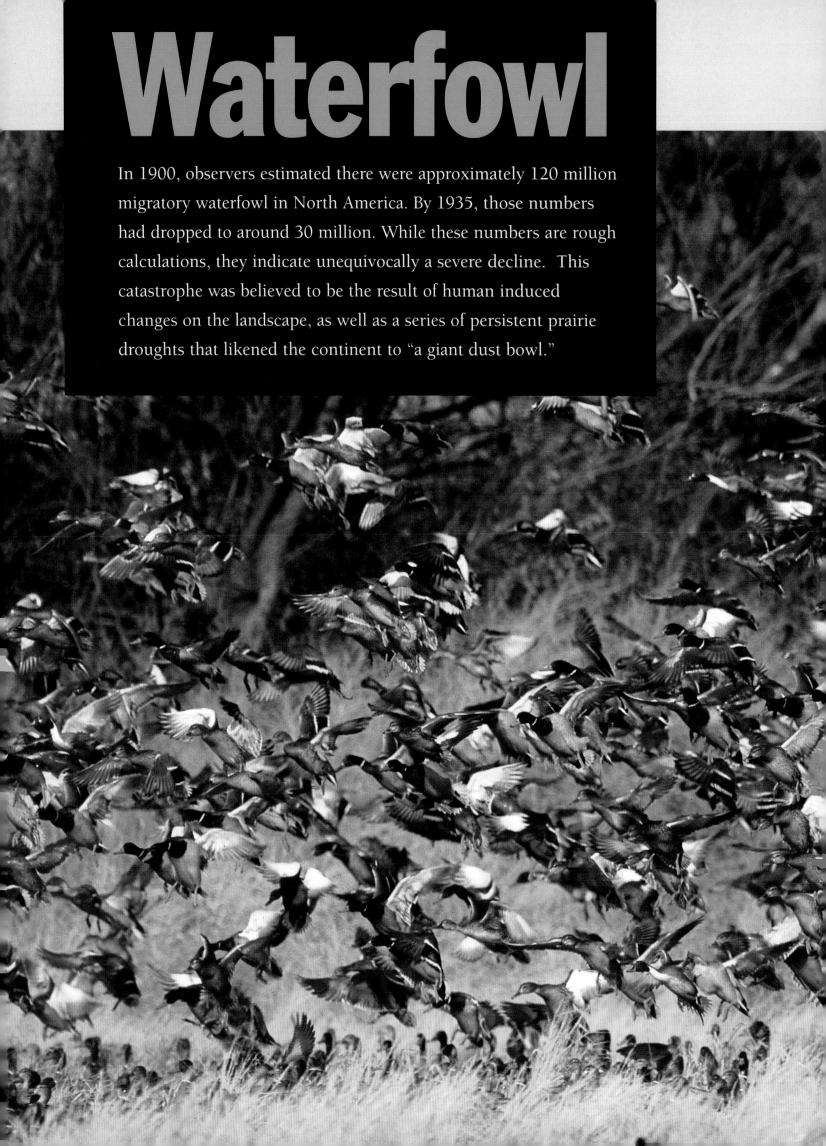

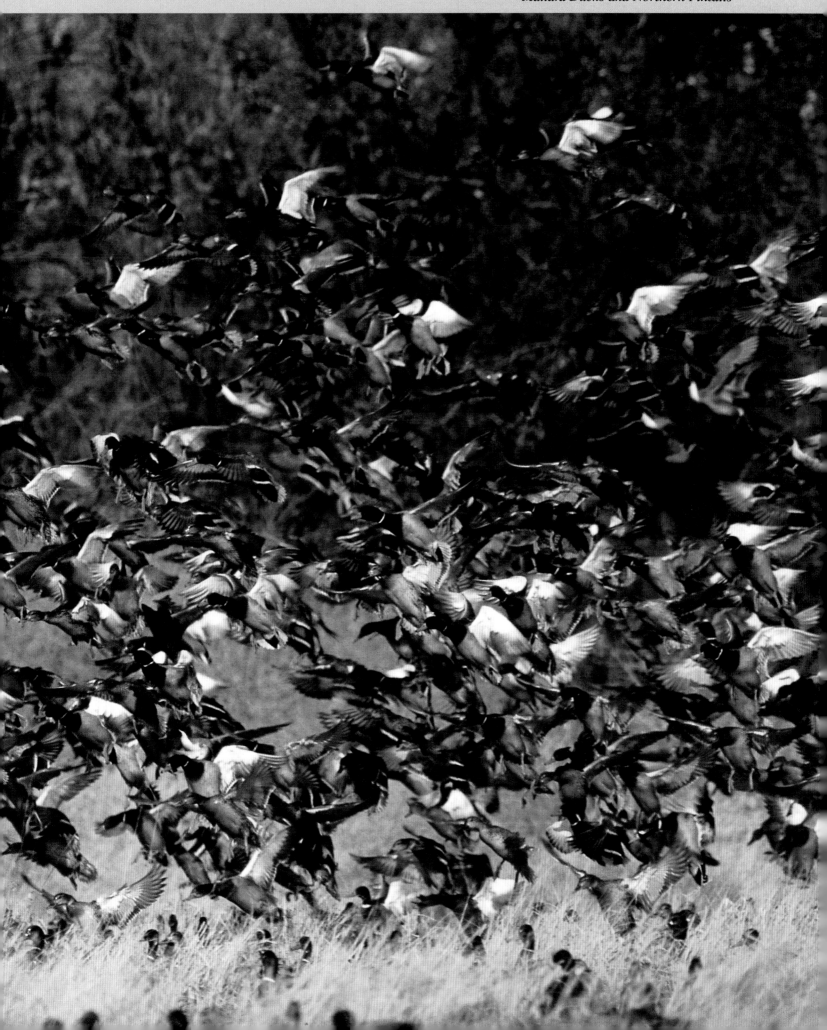

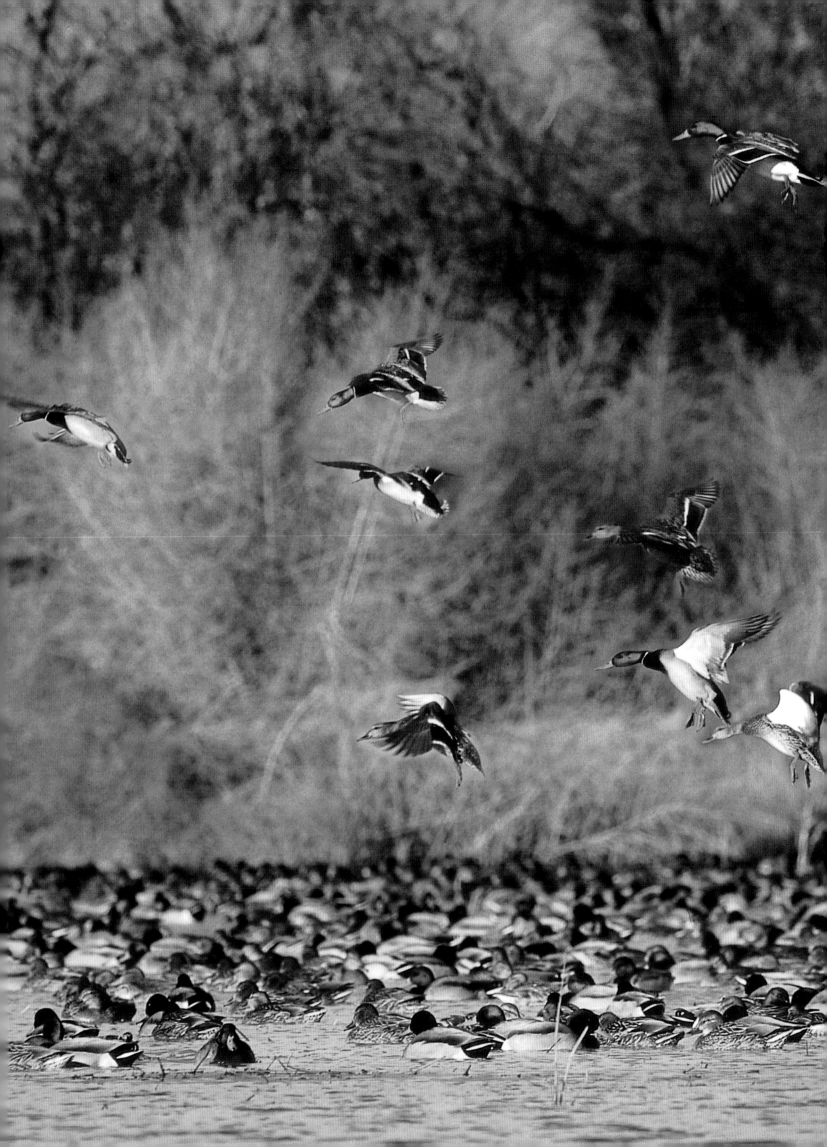

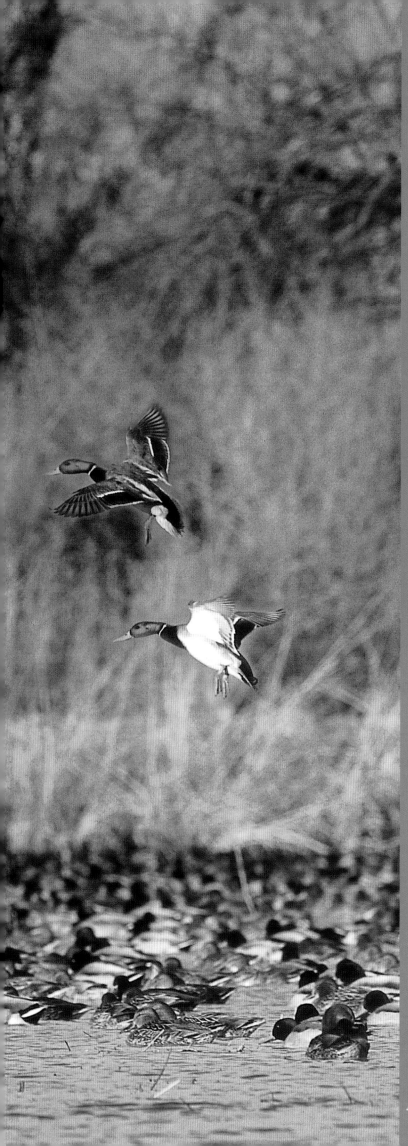

Recognizing the rapid depletion of waterfowl resources, the government set out to protect waterfowl habitats and create safe havens where birds could thrive. In 1903, President Theodore Roosevelt established the first wildlife sanctuary and set in motion a concept that was rapidly embraced. By 1939, there were 266 national wildlife refuges. Today there are more than 5,000.

Private efforts also made a difference. Ducks Unlimited was established in 1937 by a group of concerned waterfowl hunters, who, like Roosevelt, were passionate sportsmen and felt a deep connection to the land and the wildlife it supported. Over the years, other wildlife groups succeeded in mobilizing thousands of concerned citizens.

By 1945, waterfowl populations had rebounded to approximately 100 million, fueling momentum, action, and enthusiasm for wetlands. It was an era when gratified champions of conservation referred fondly to wetlands as "duck hotels" and "outdoor hostelries."

Sandhill Crane

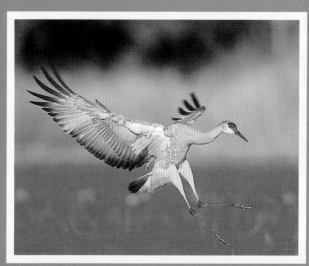

Mallard Ducks

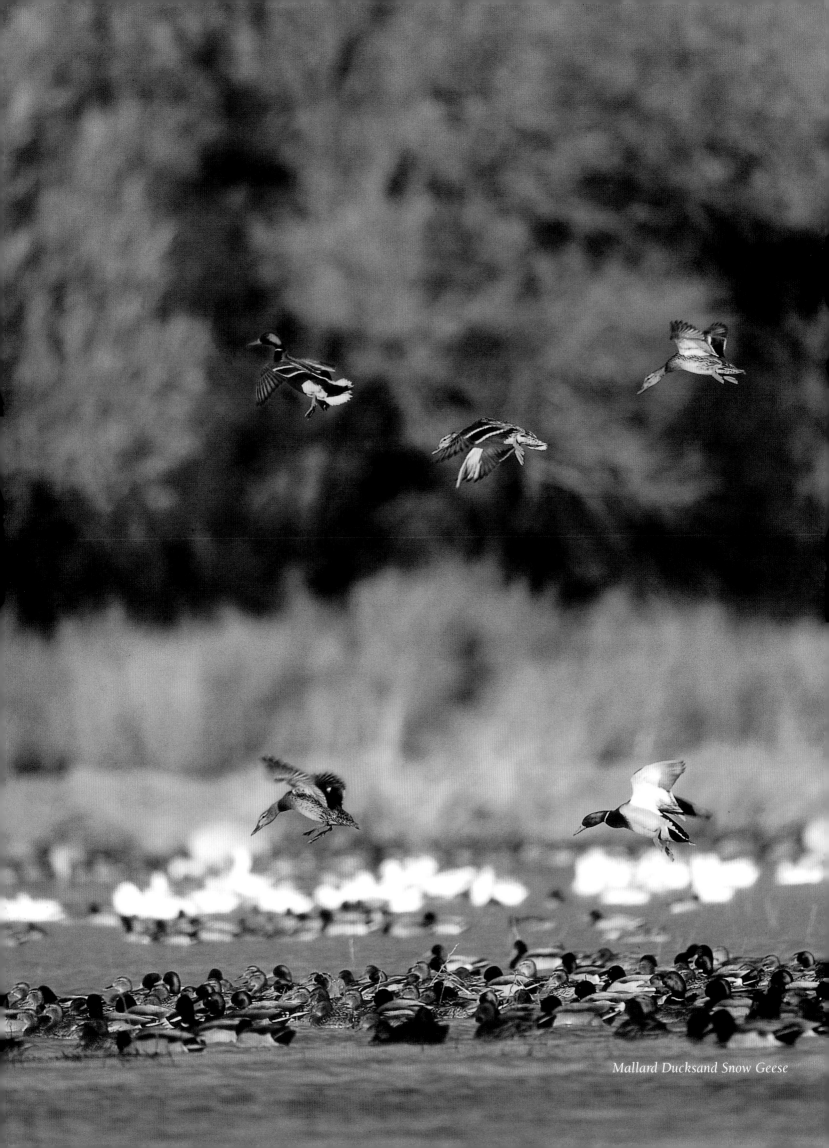

Mallard Ducksand Snow Geese

As knowledge about natural resources grew, a spirit of optimism emerged. "Conservation Aids Defense," read a 1940s headline in a Department of the Interior press release. "Conservation of wildlife is one way of making a country worth living in — a first essential in inspiring zealous defense," said a government biologist. After World War II, the process of counting ducks was enhanced by the use of government aircraft no longer necessary for national defense.

Since that time, monitoring waterfowl populations has developed into an even more highly evolved, scientific enterprise, which in turn has fueled understanding and greater safeguarding of wild places.

What was true in 1940 resounds in the new millennium with continued relevance.

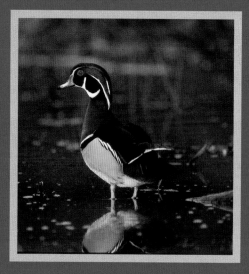

Wood Duck

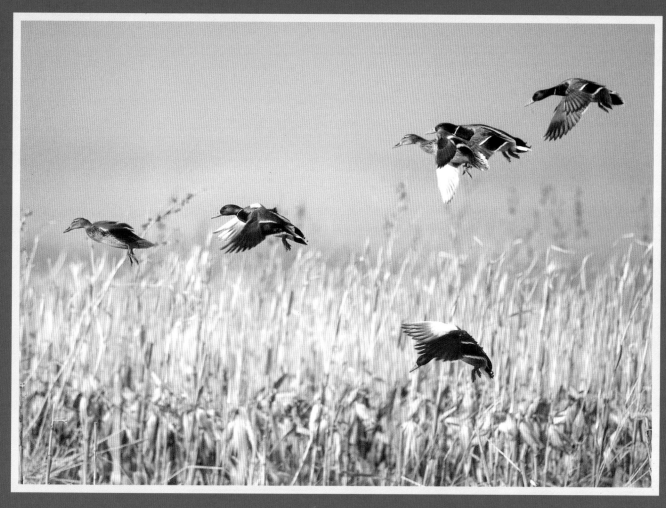

Mallard Ducks

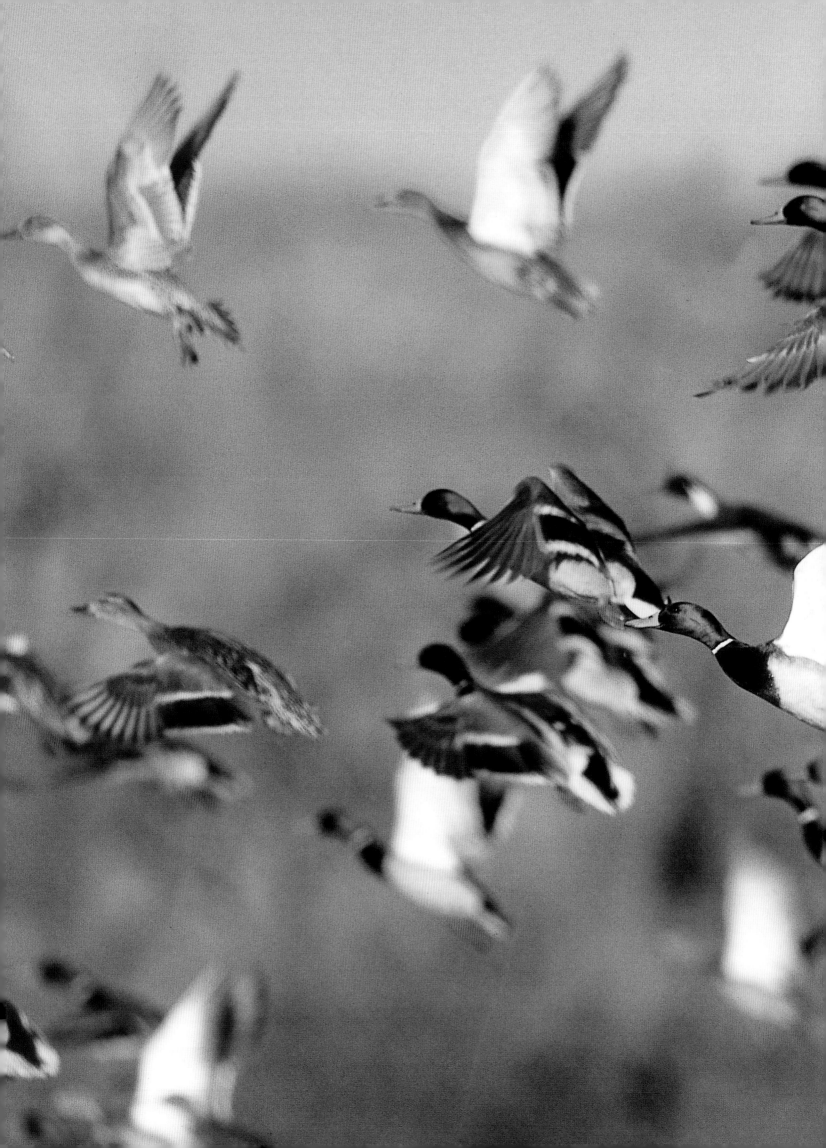

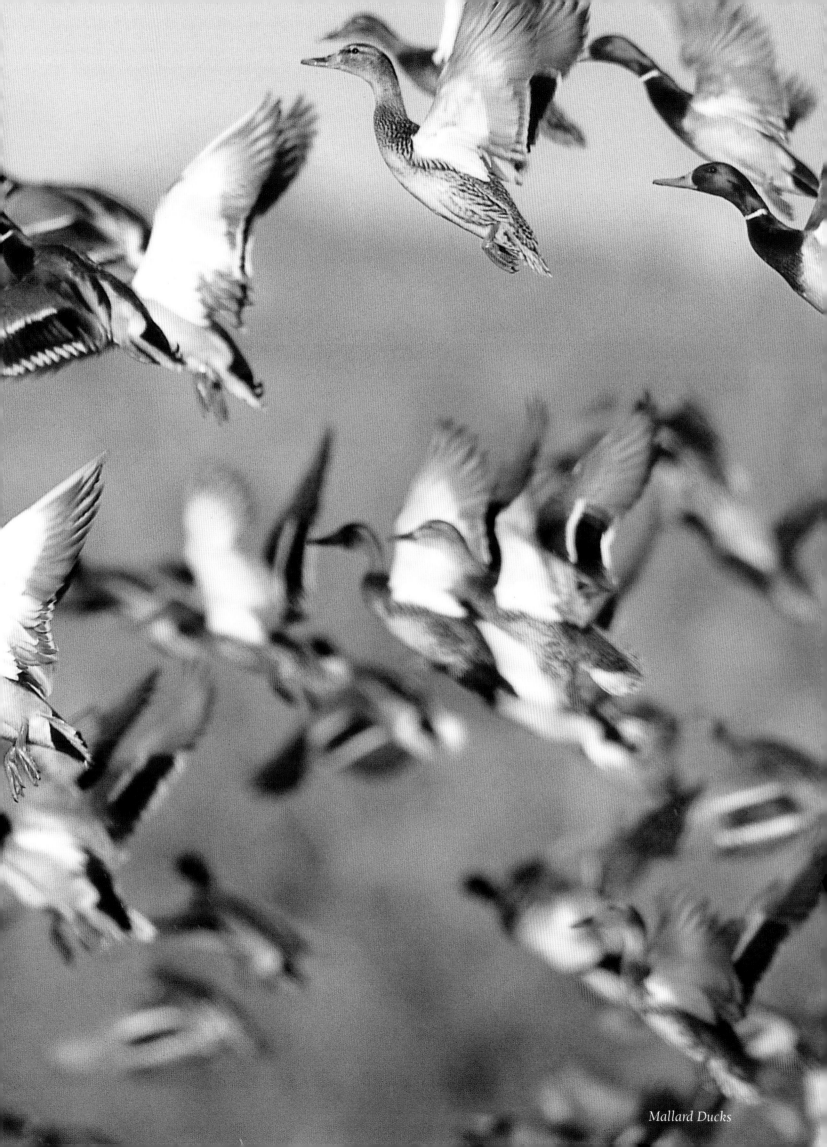

Mallard Ducks

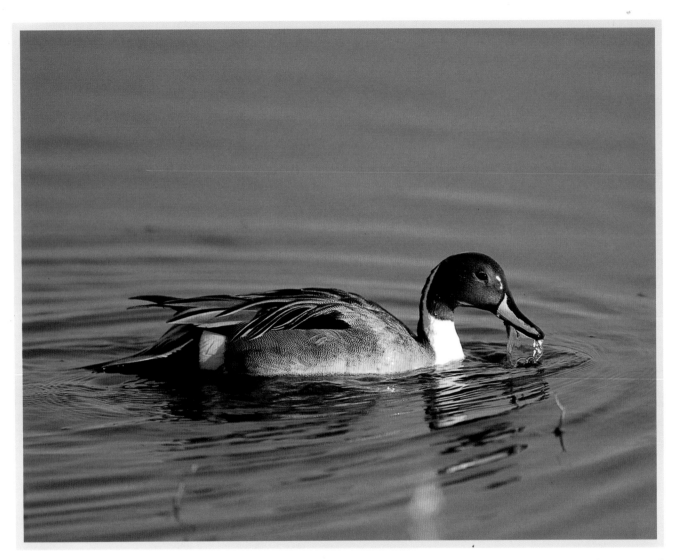

Northern Pintail

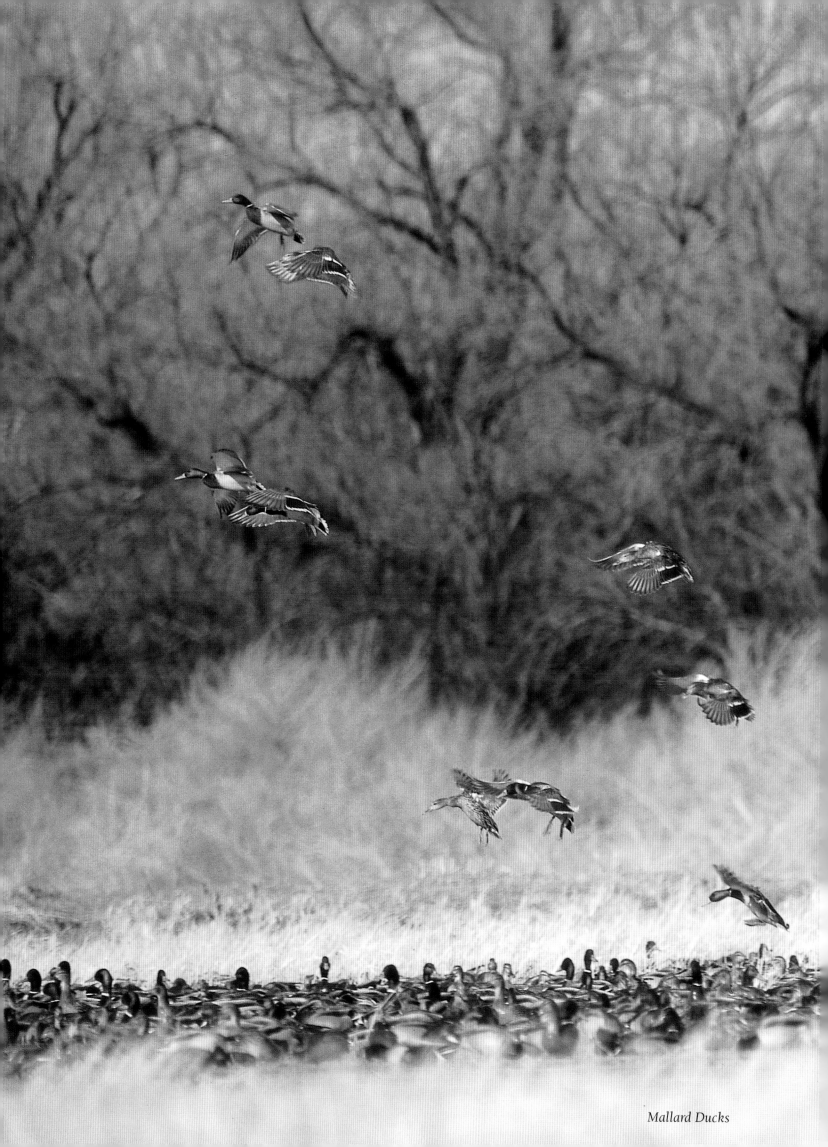

Mallard Ducks

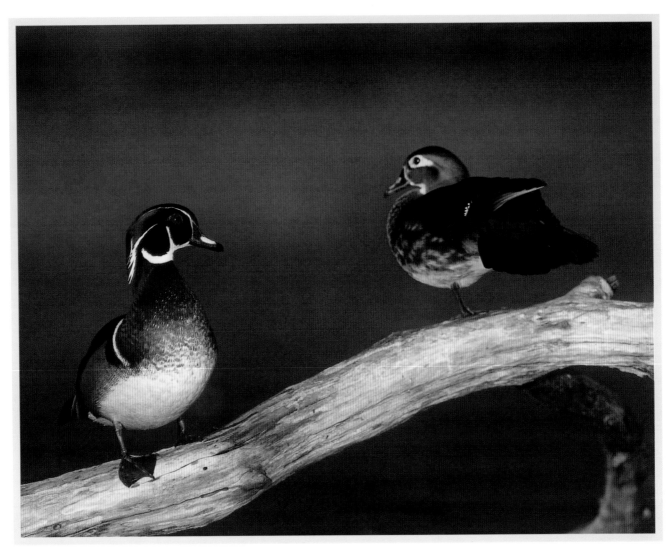

Wood Ducks

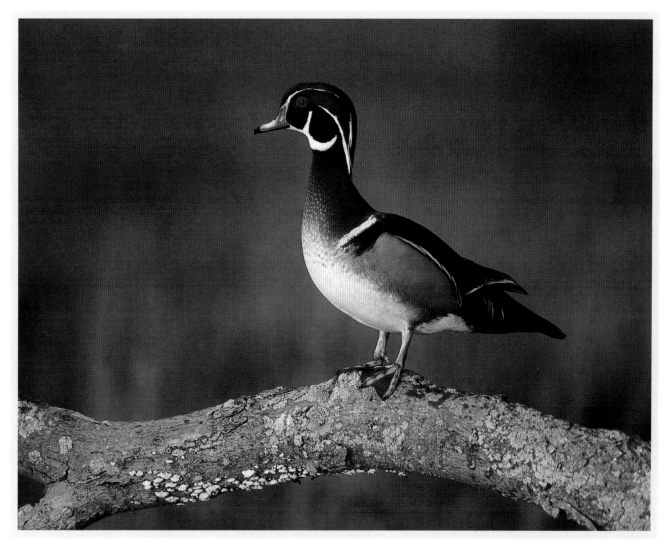

Wood Duck

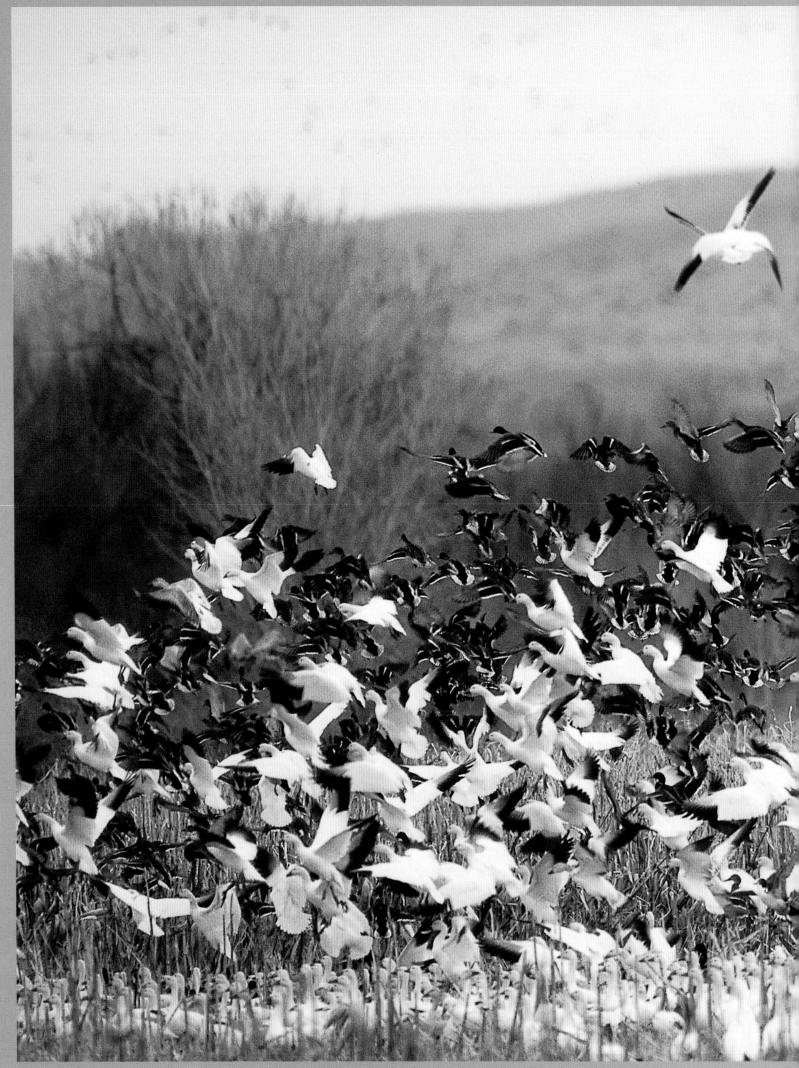

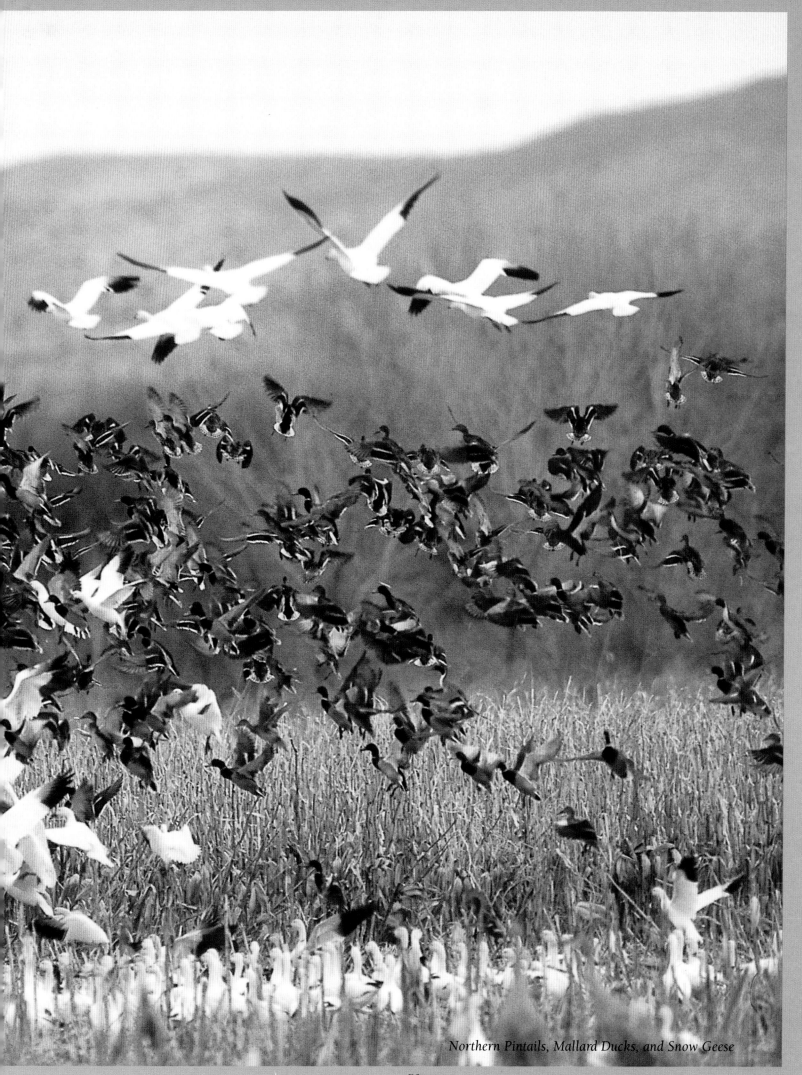

Northern Pintails, Mallard Ducks, and Snow Geese

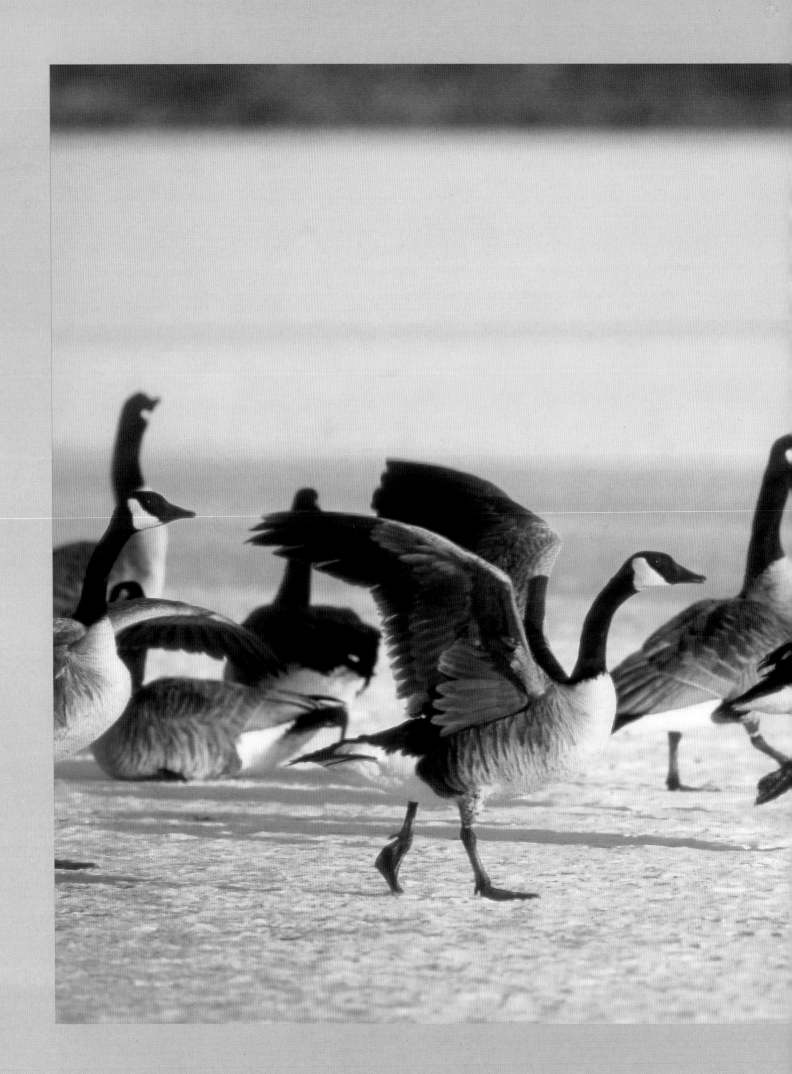

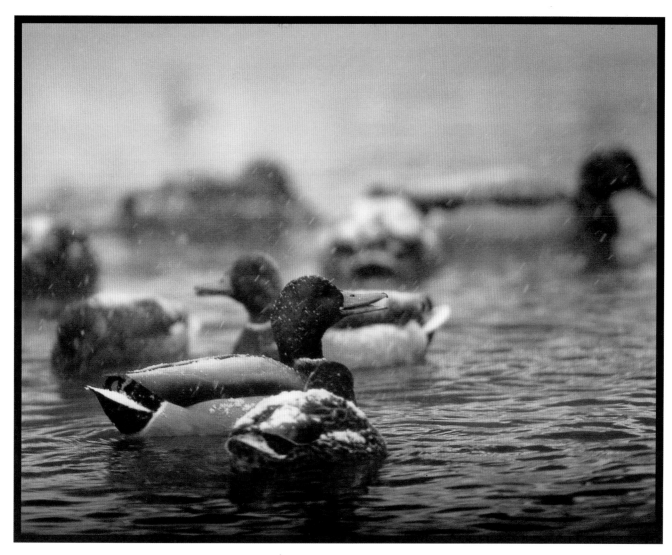

Mallard Ducks

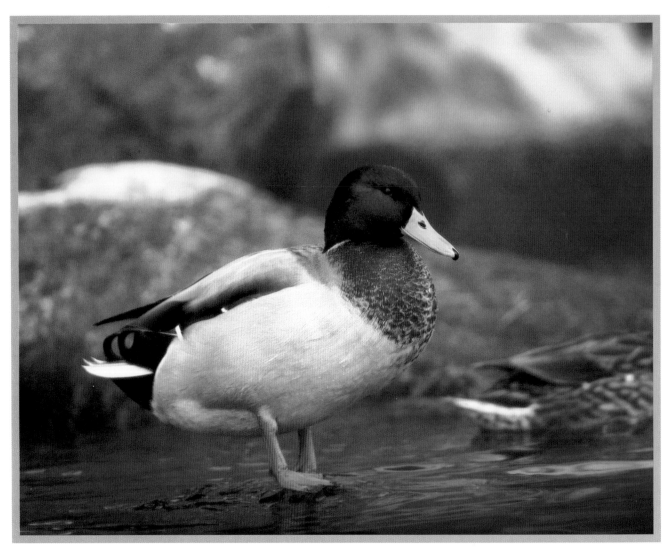

Mallard Duck

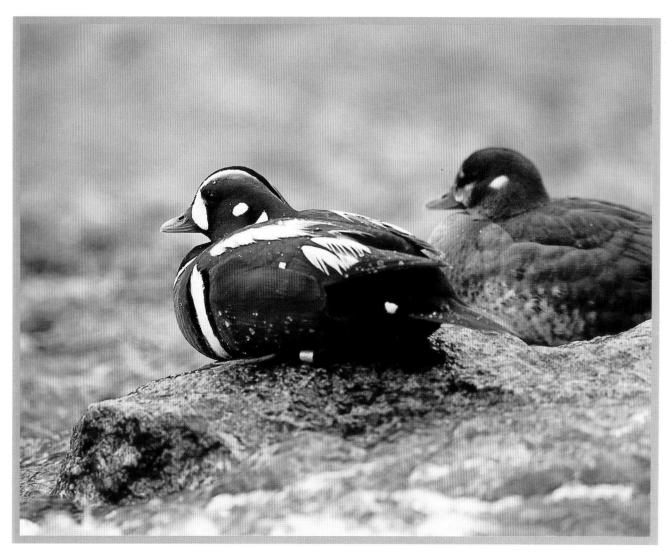

Harlequin Ducks

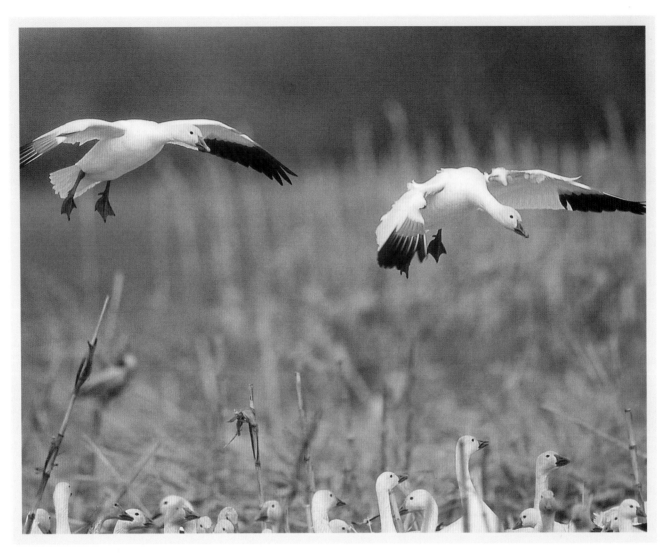

Snow Geese

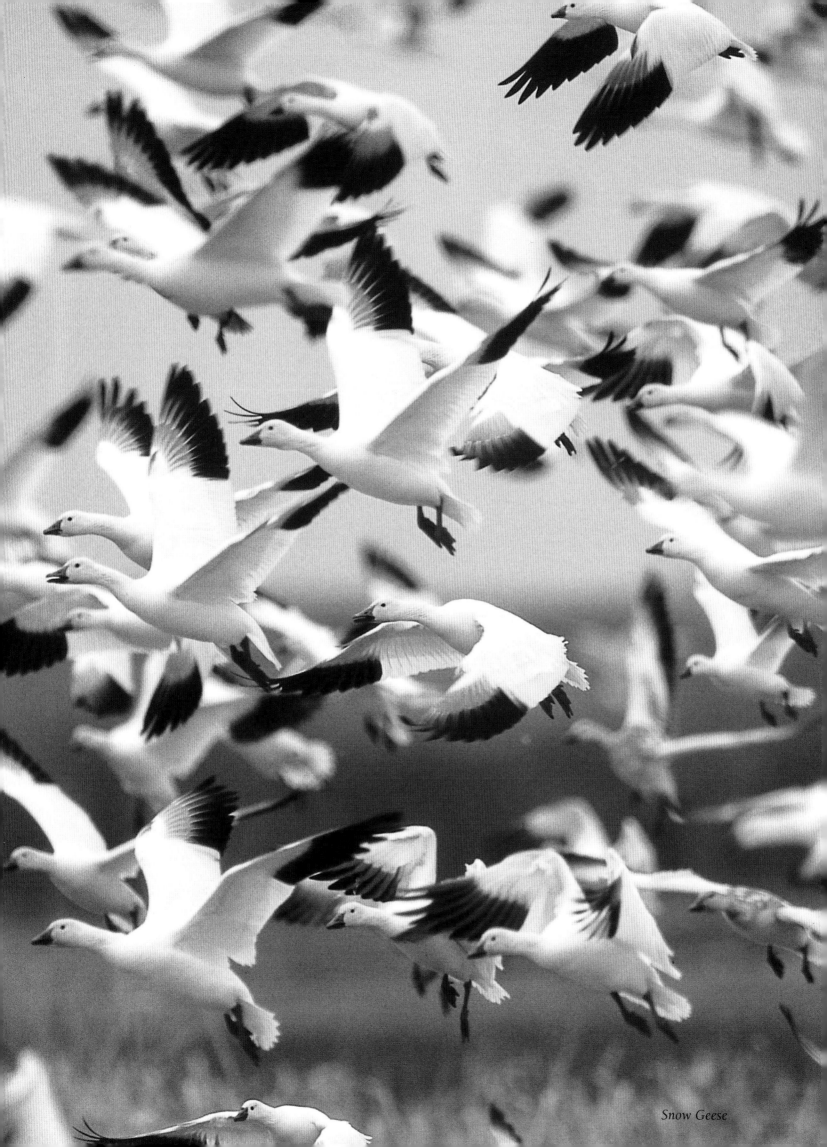

Snow Geese

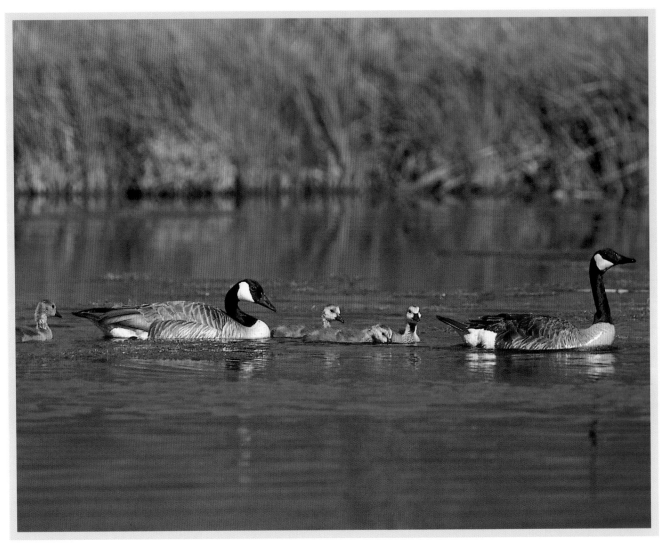

Canada Geese

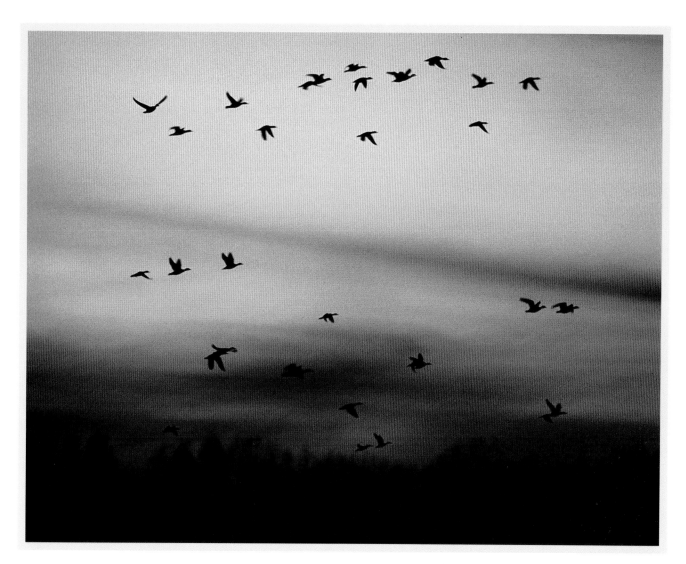

Mallard Ducks

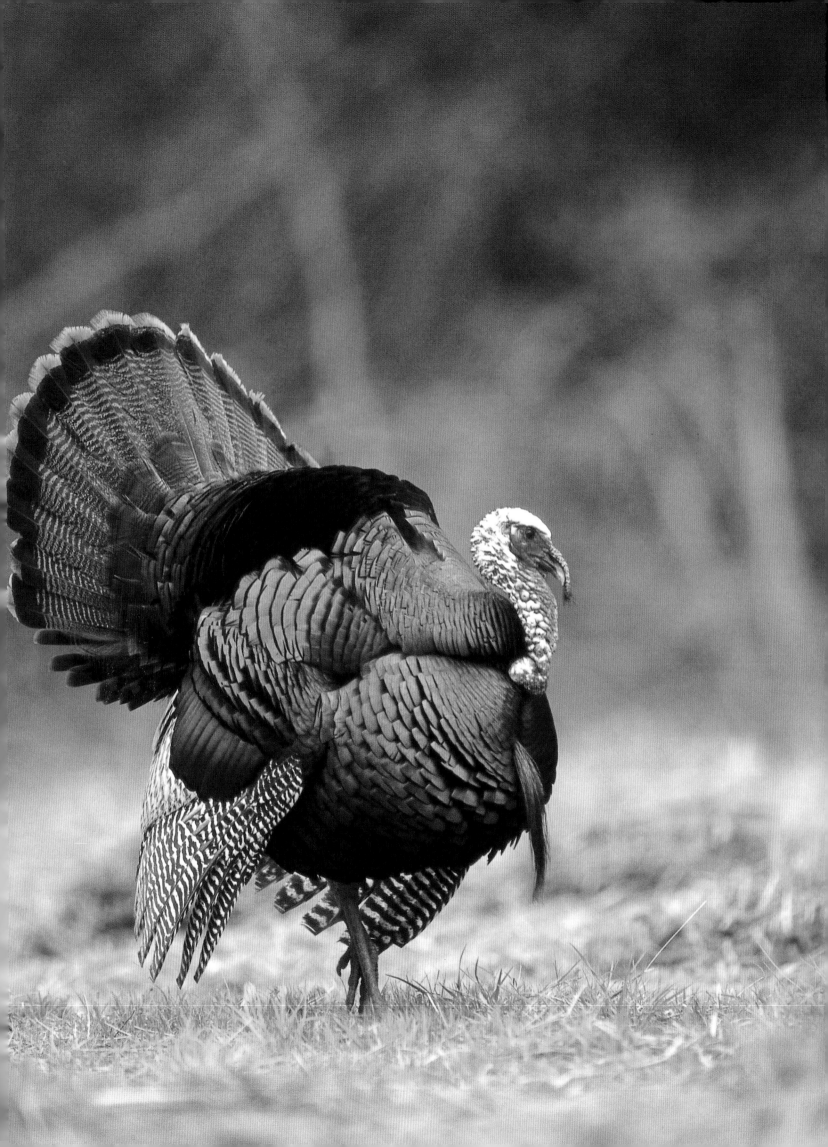

Eastern Wild Turkeys

Prior to the arrival of Columbus in 1492, it is believed there were 7 to 10 million wild turkeys roaming North America. By the turn of the 20th century, those numbers had dwindled to approximately 30,000 birds. The North American wild turkey actually disappeared from 18 of the 39 states that were part of its historical range.

For the next three decades, unregulated hunting and habitat destruction continued to push turkey numbers to near extinction. It was not until the 1930s that the wild turkey began its slow recovery. The return of suitable habitat, along with enactment of game laws, set the stage for the restoration of the turkey.

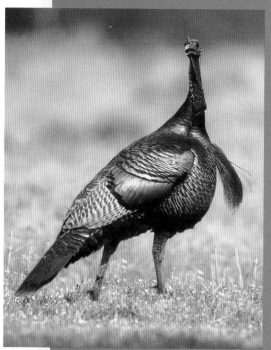

Wild turkey numbers started to steadily increase after World War II. State game agencies implemented trapping and relocating programs that sped up the process. These efforts brought wild turkey populations to 1.3 million by the early 1970s.

The founding of the National Wild Turkey Federation (NWTF) in 1973 helped accelerate the wild turkey's growth by unifying the efforts of grassroots volunteers, state and federal wildlife agencies, and corporations. Thanks to the work of government wildlife agencies and the NWTF's many volunteers and partners, today's population numbers are estimated at 5.6 million birds.

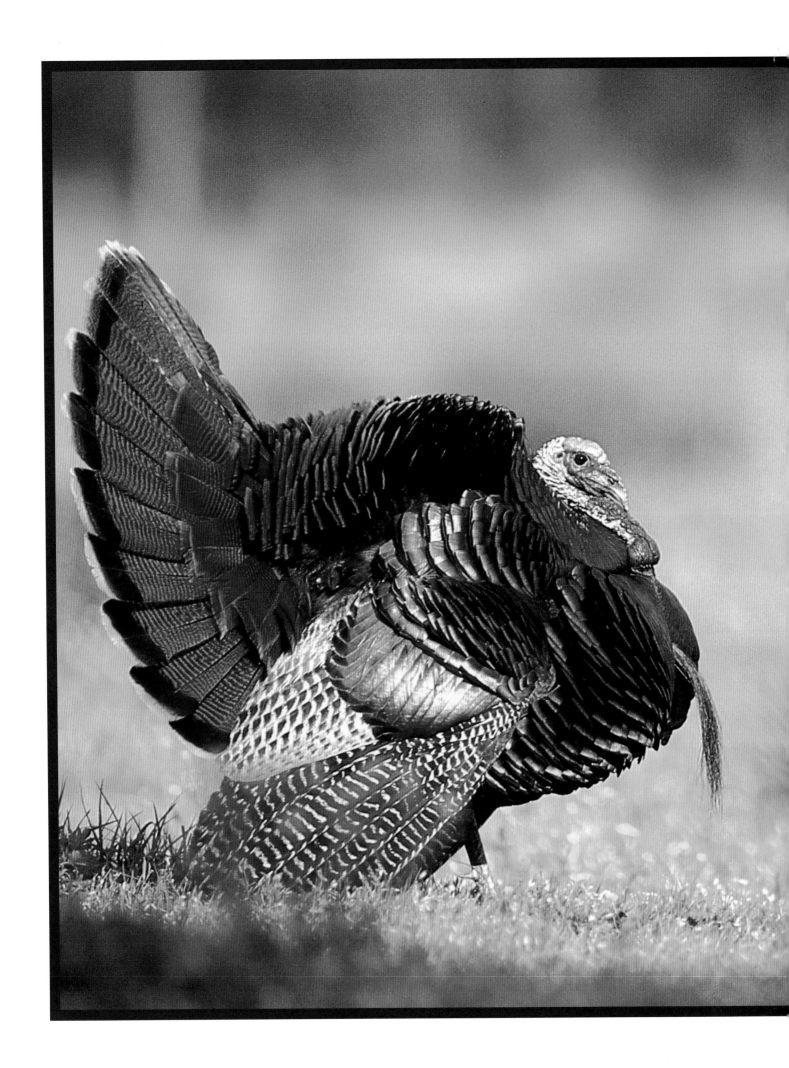

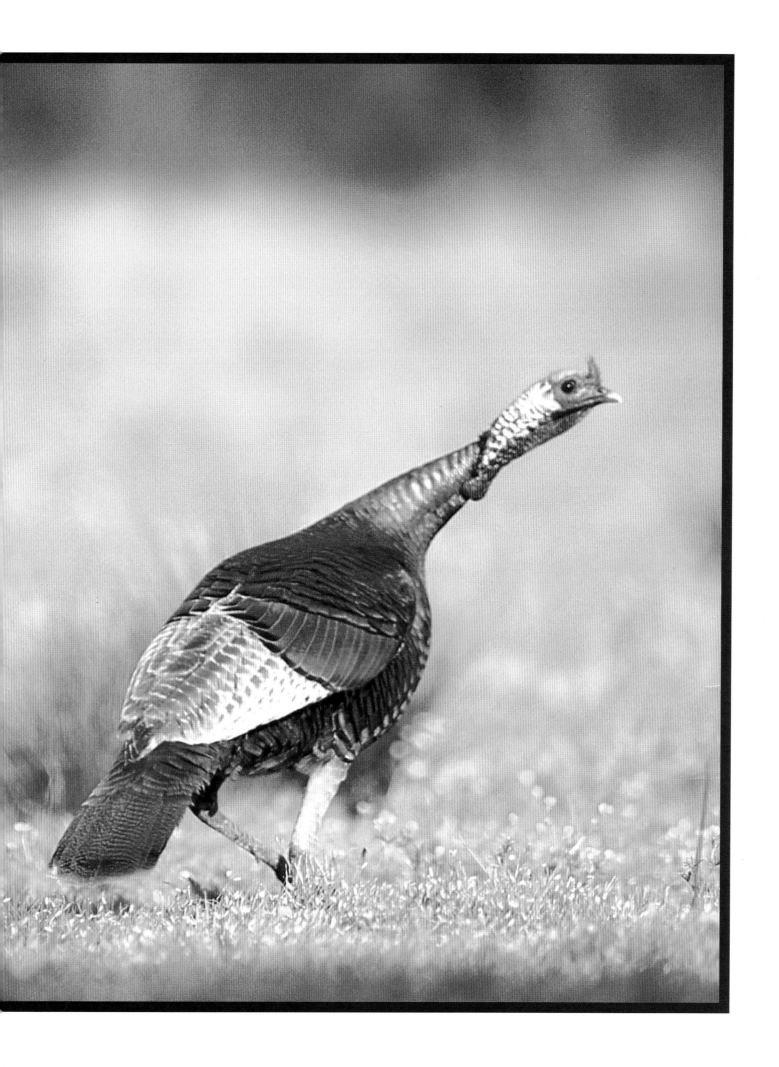

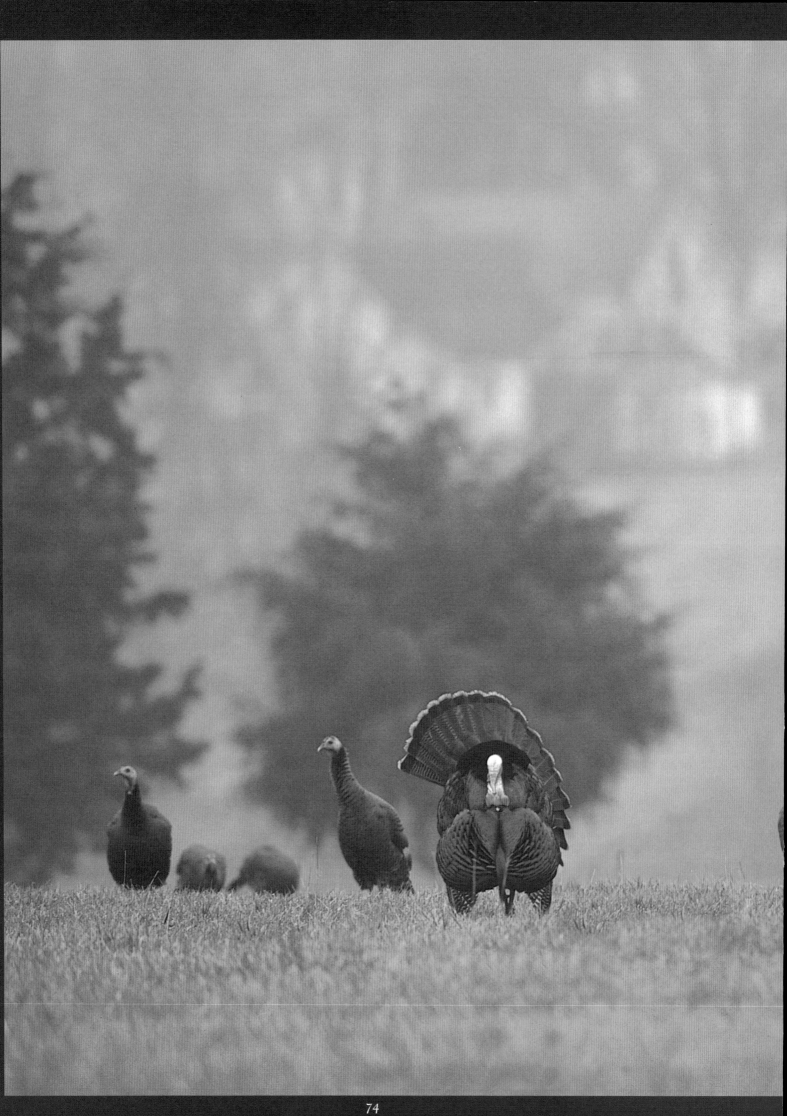

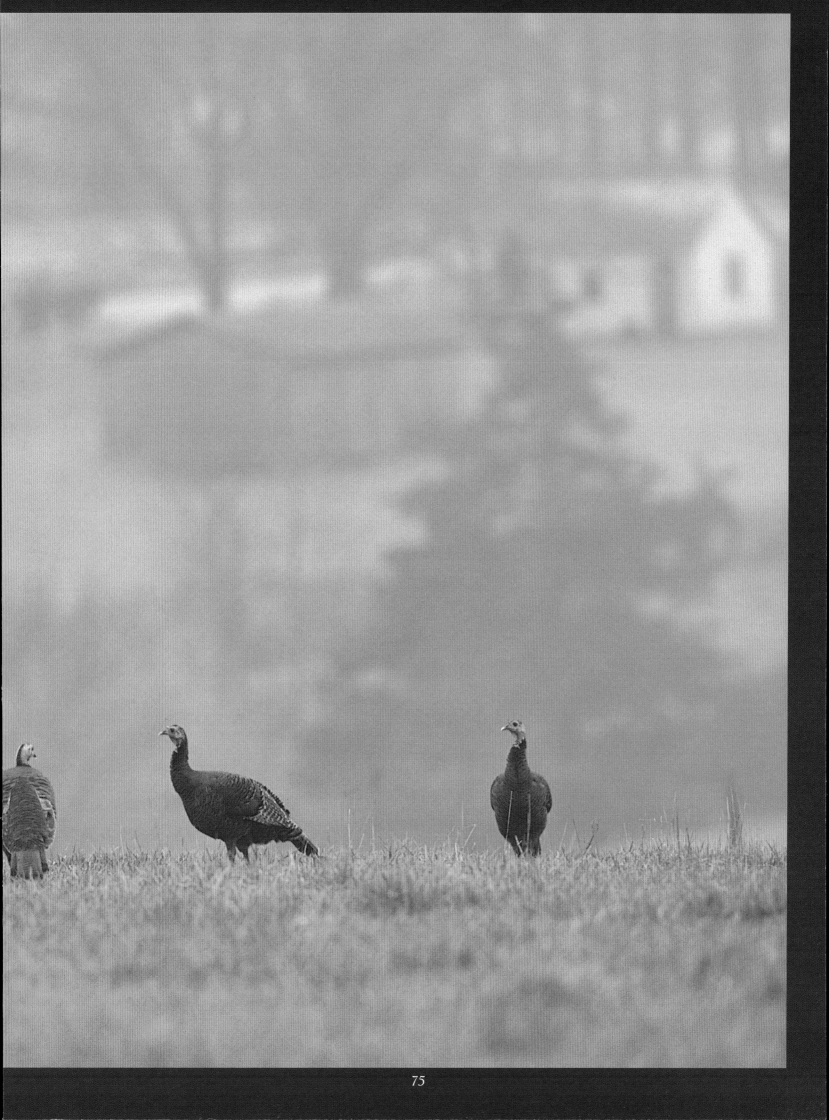

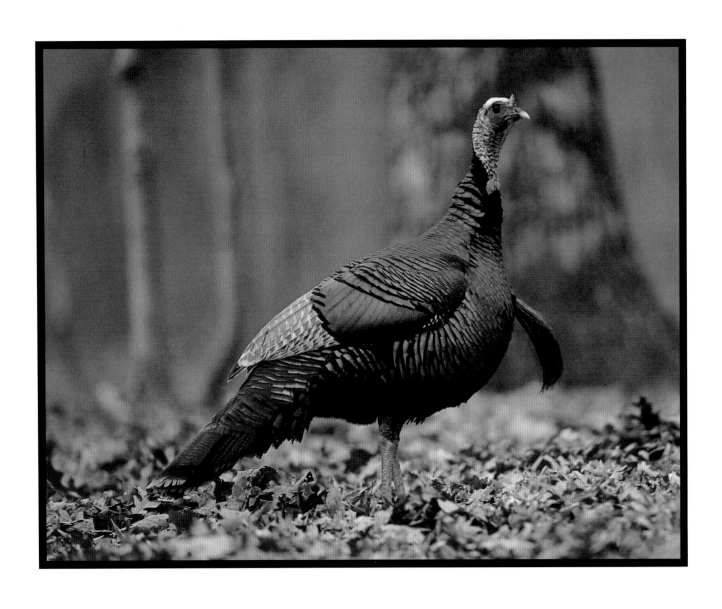

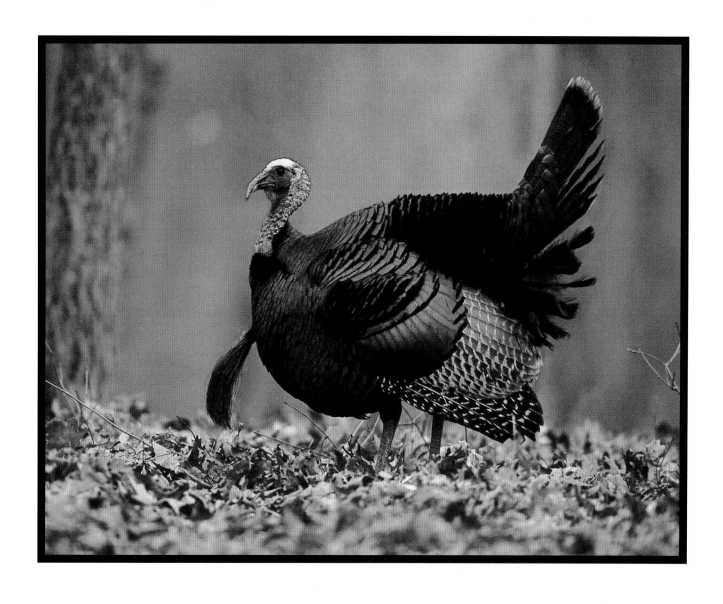

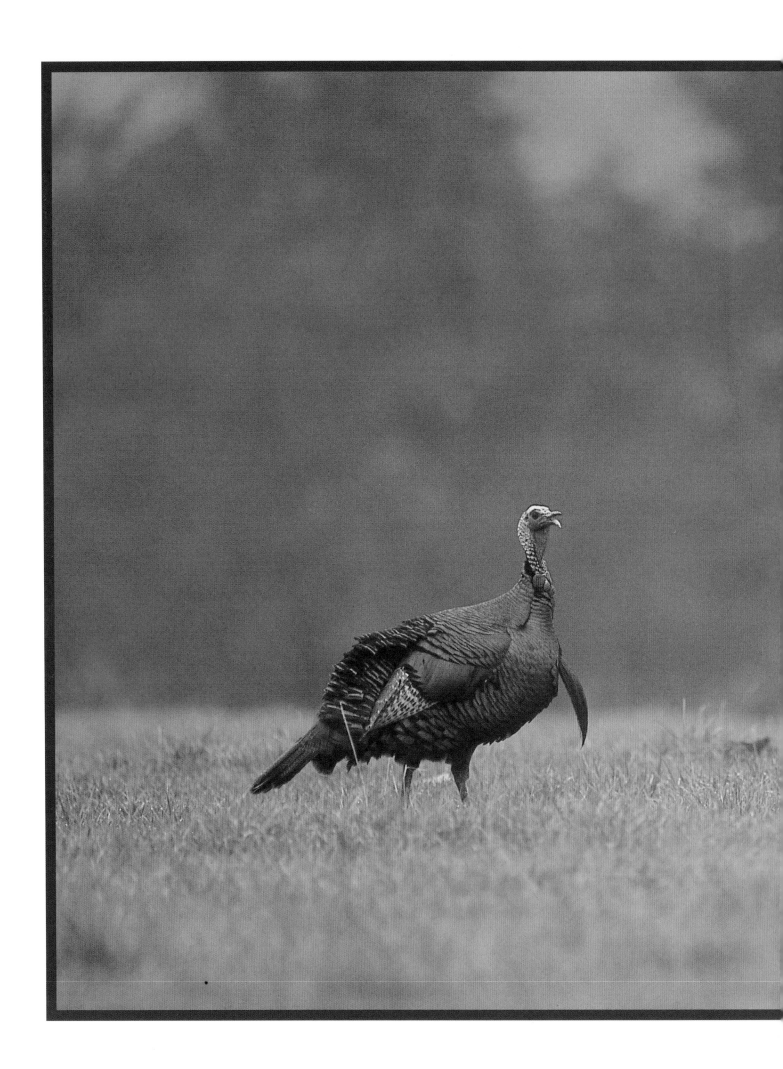

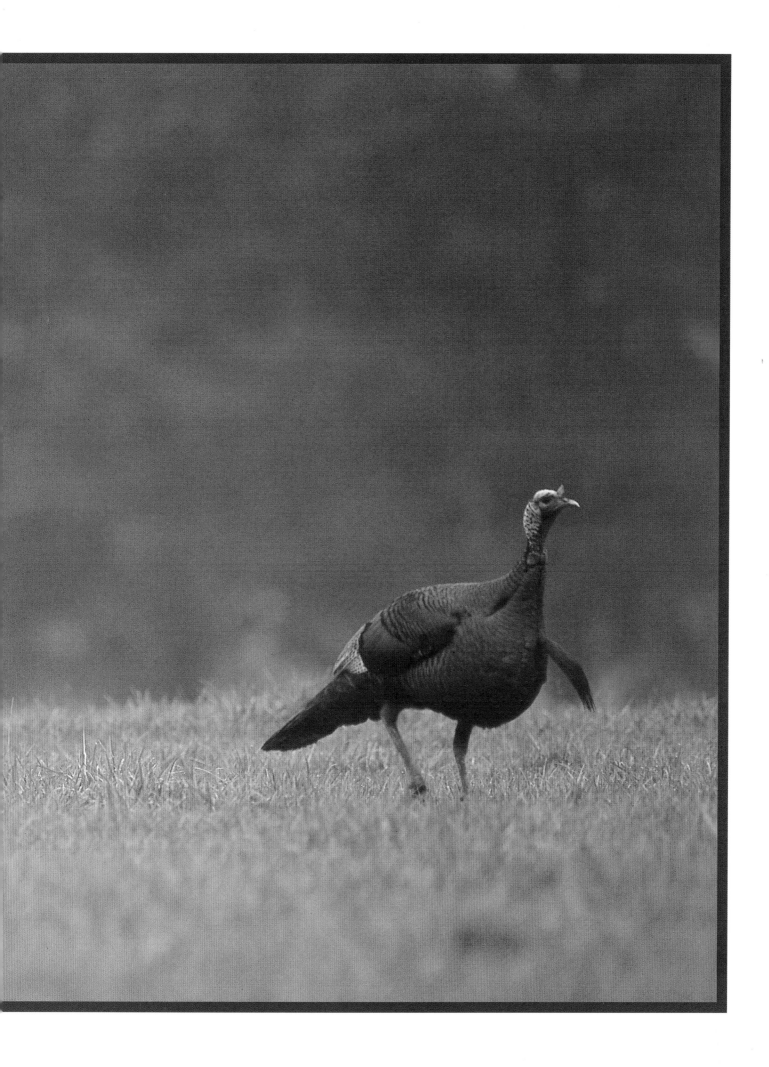

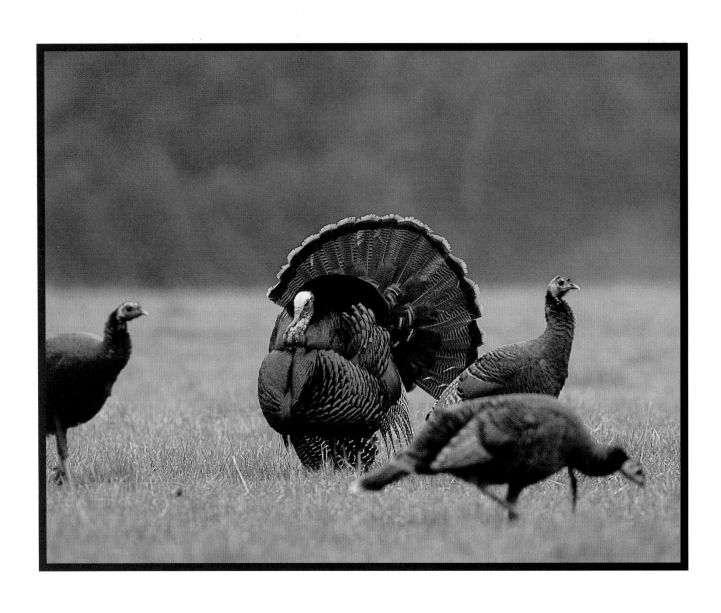

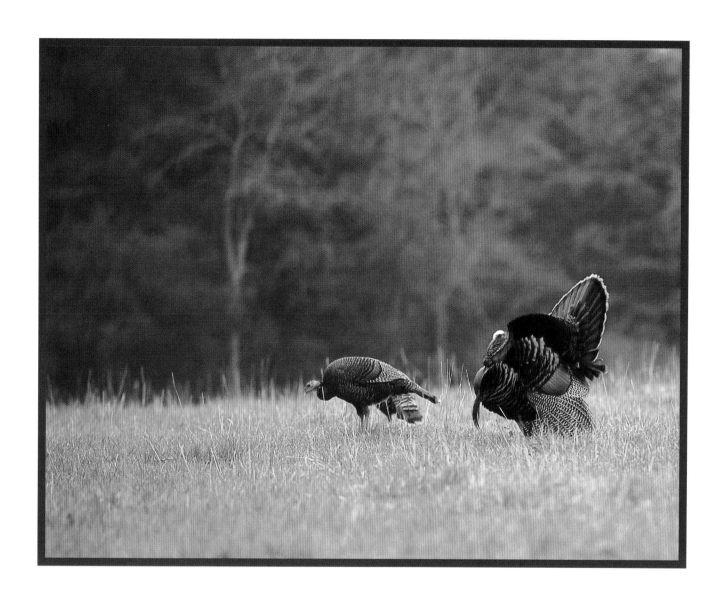

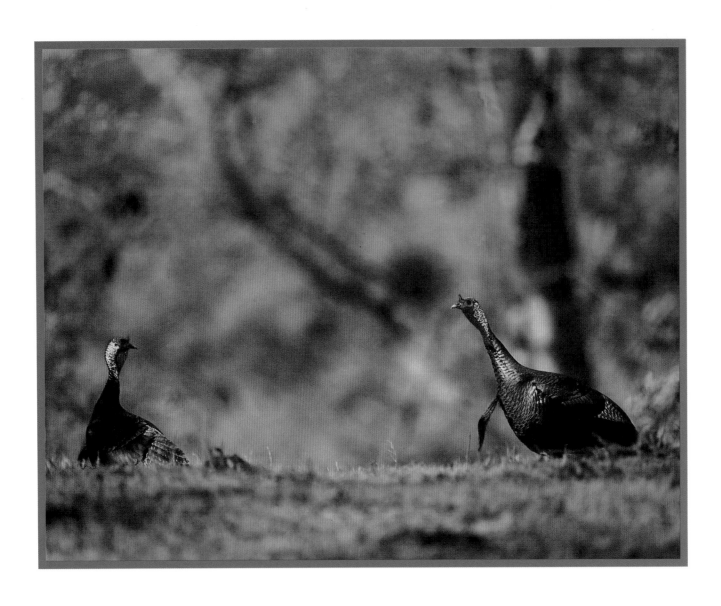

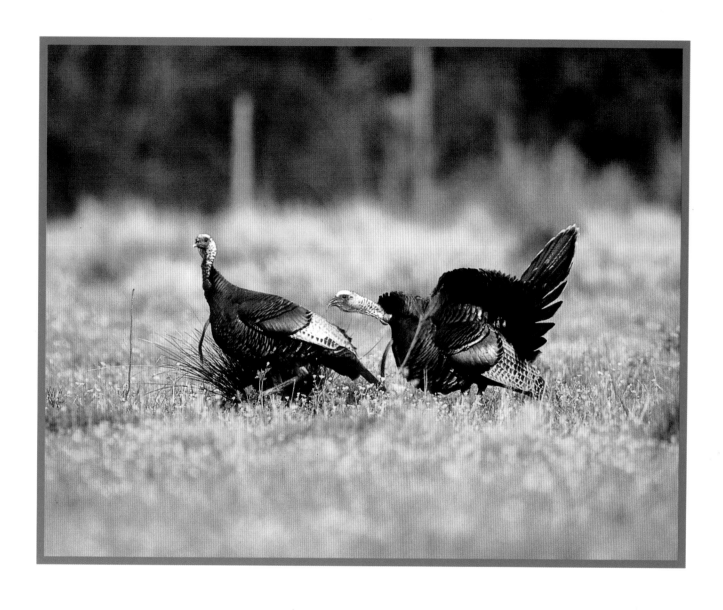

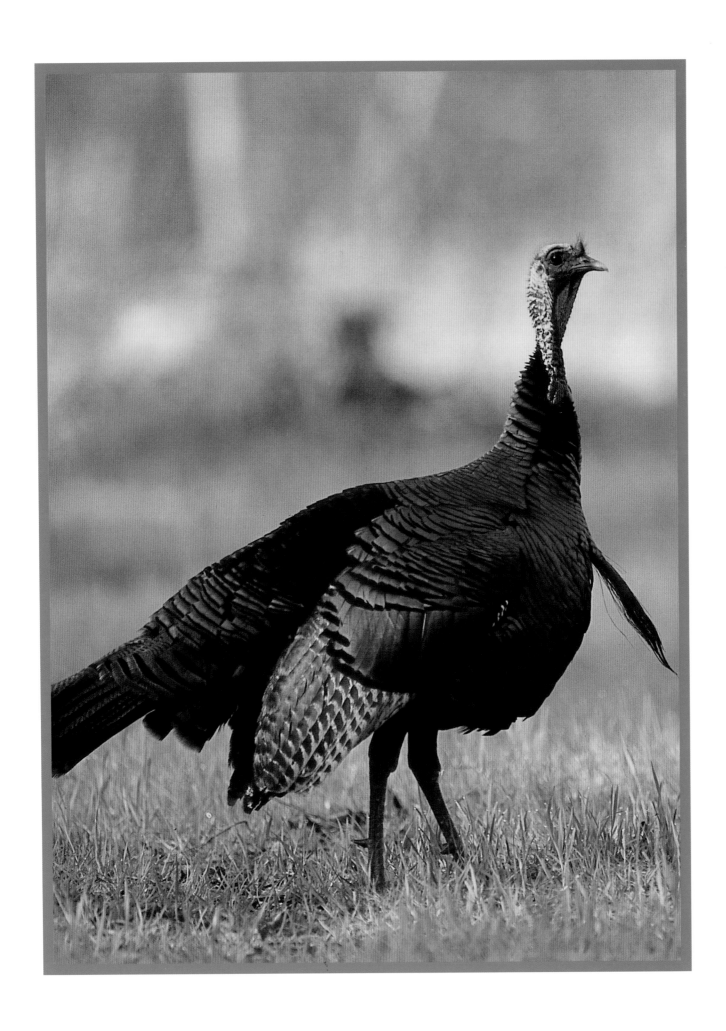

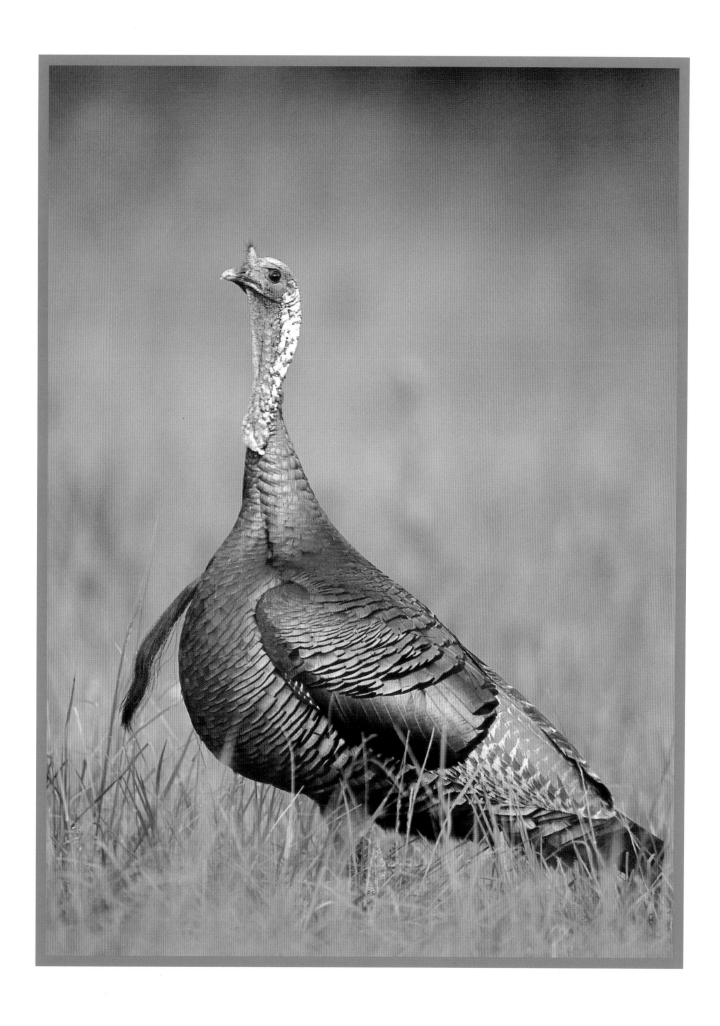

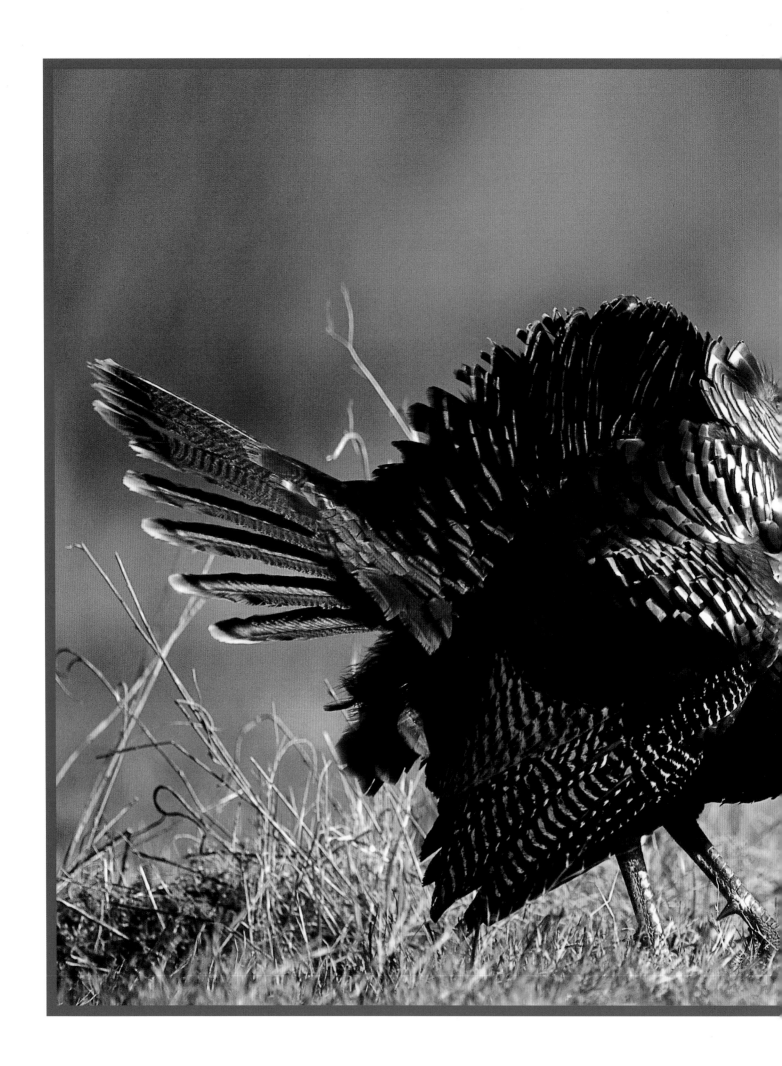

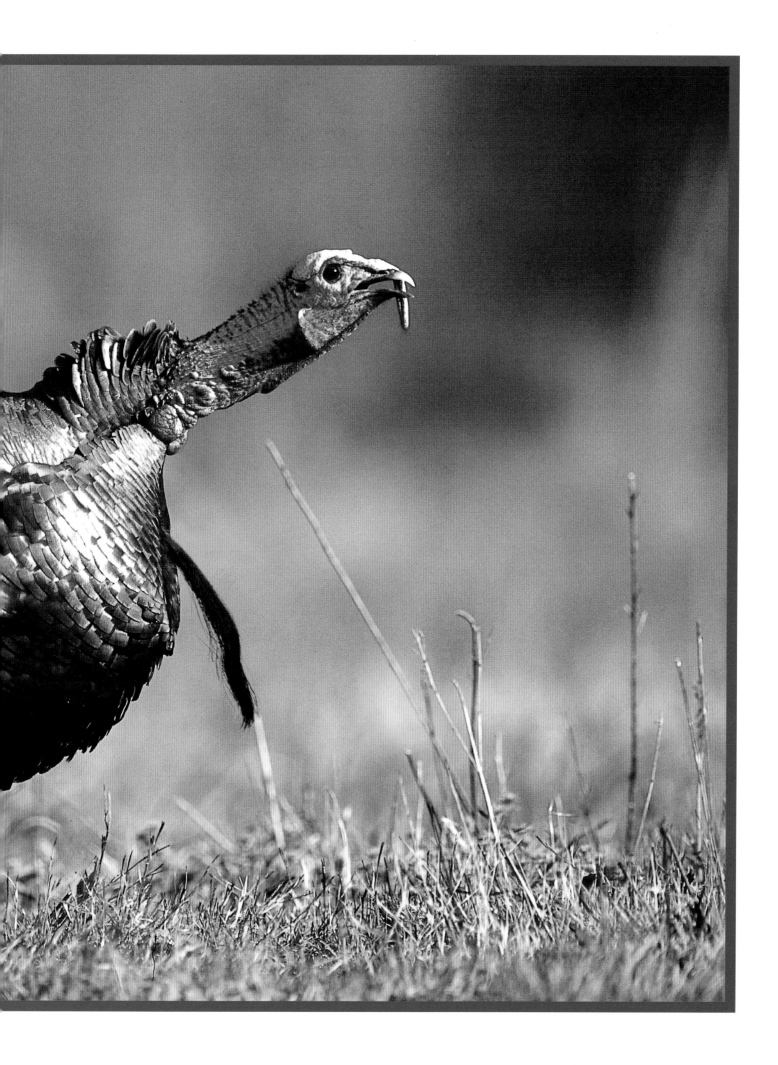

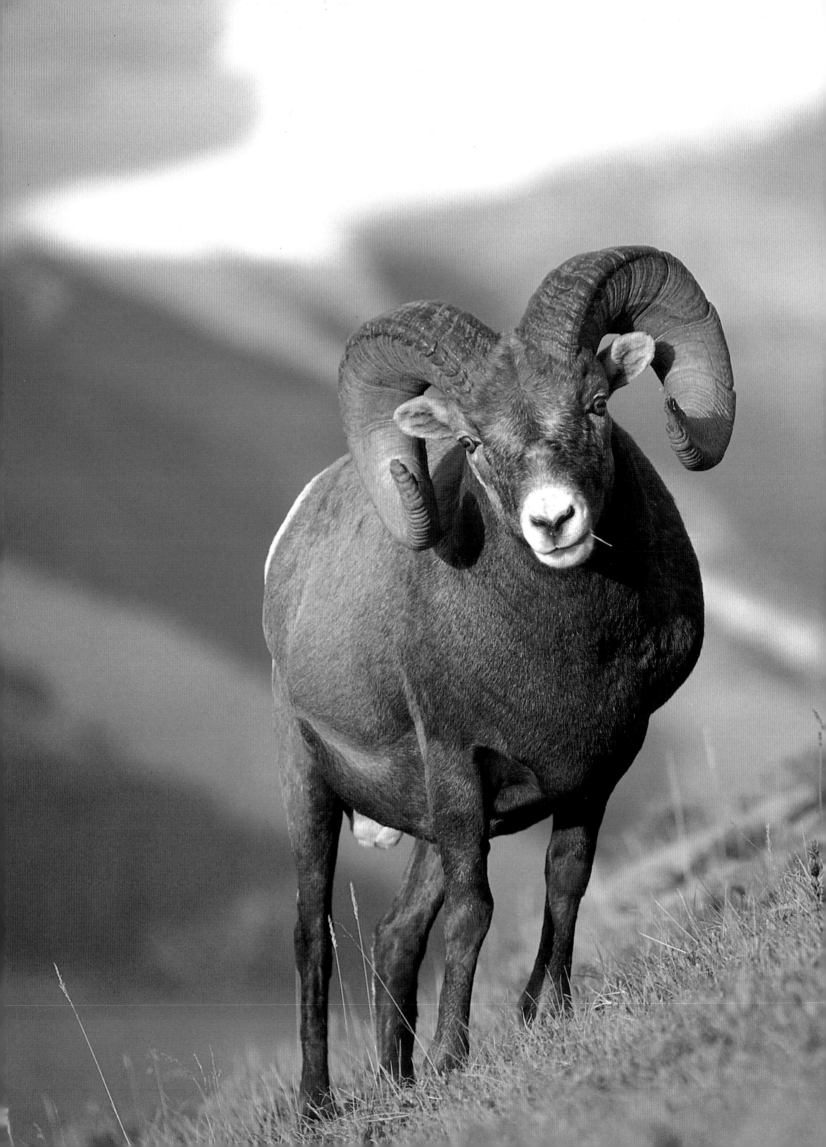

BIGHORN SHEEP

In 1977, it was estimated that fewer than 50,000 bighorn sheep remained in North America. Today that number has risen to over 200,000, and bighorn sheep have been returned to many states where their numbers had been decimated by man's activities.

The Foundation for North American Wild Sheep (FNAWS) was incorporated in 1977 by a group of bighorn sheep hunters. The FNAWS' mission is to promote and enhance bighorn sheep populations throughout North America, to safeguard against their decline, and to fund programs for the professional management of these populations – all while keeping administrative costs to a minimum. The Foundation has directly funded many state, province, and tribal game and fish agencies' efforts to enhance habitat and transplant bighorn sheep.

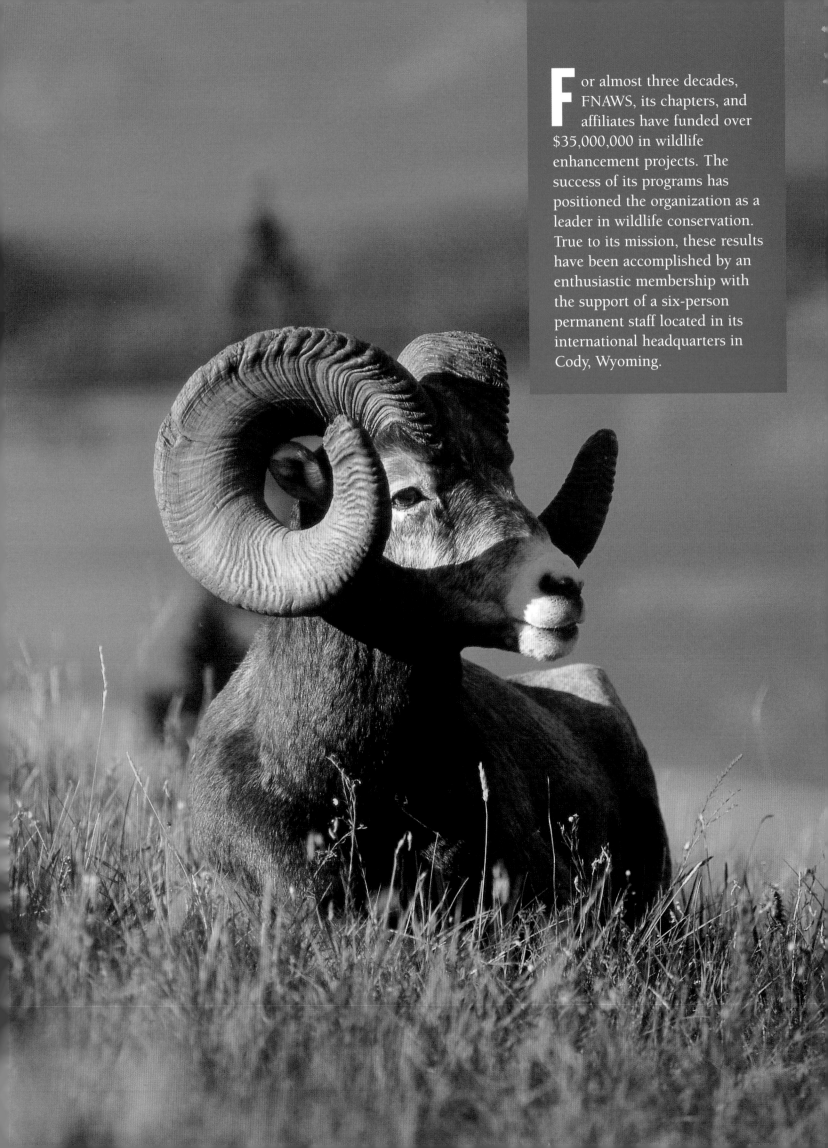

For almost three decades, FNAWS, its chapters, and affiliates have funded over $35,000,000 in wildlife enhancement projects. The success of its programs has positioned the organization as a leader in wildlife conservation. True to its mission, these results have been accomplished by an enthusiastic membership with the support of a six-person permanent staff located in its international headquarters in Cody, Wyoming.

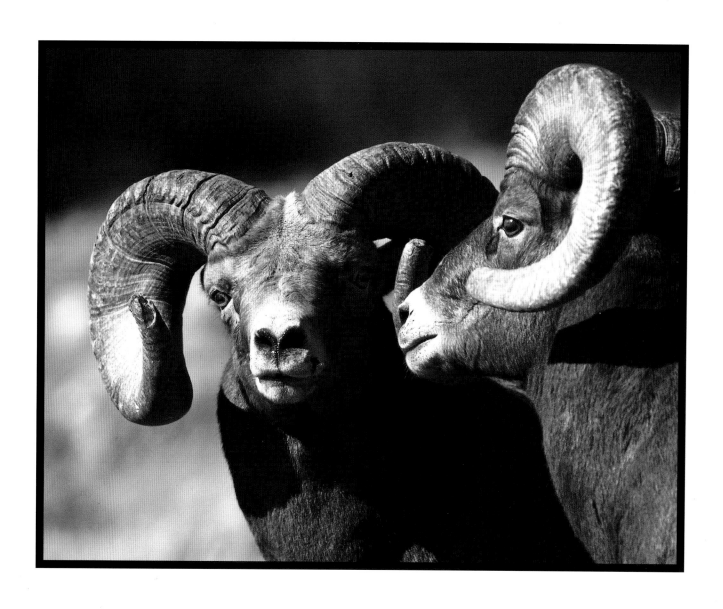

GRAY WOLVES

Perhaps no other species has been the center of more controversy than the wolf. Attitudes toward wolves vary, but most surveys indicate a majority of Americans are in favor of restoring wolves to their natural ranges. The controversy over the wolf continues into conservation groups, who differ on how to accomplish the task of wolf restoration.

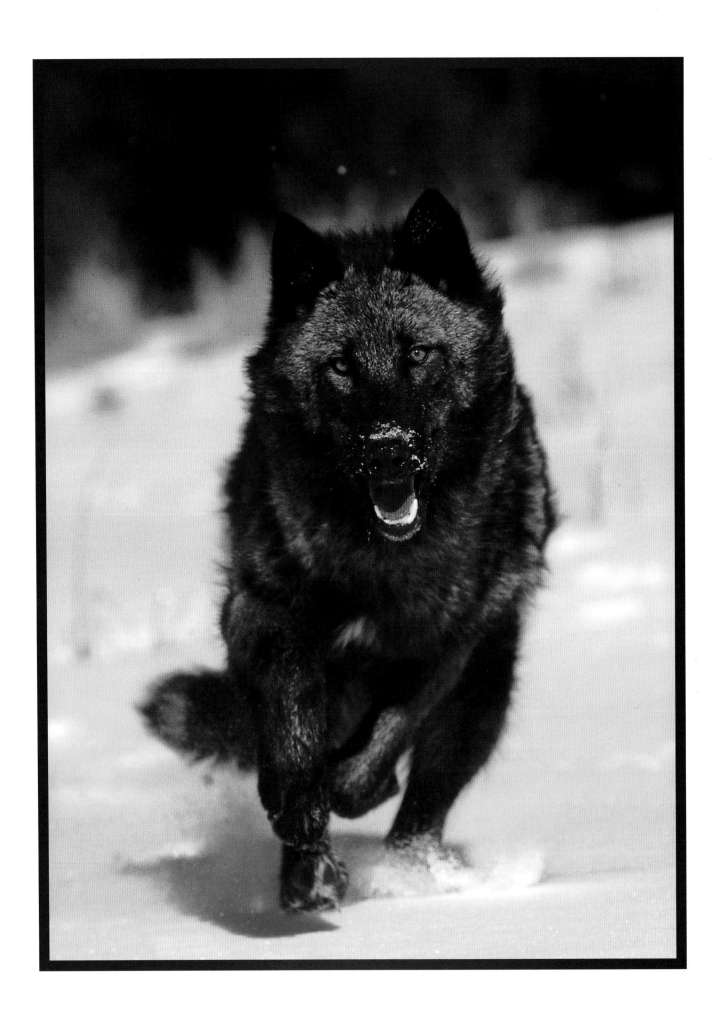

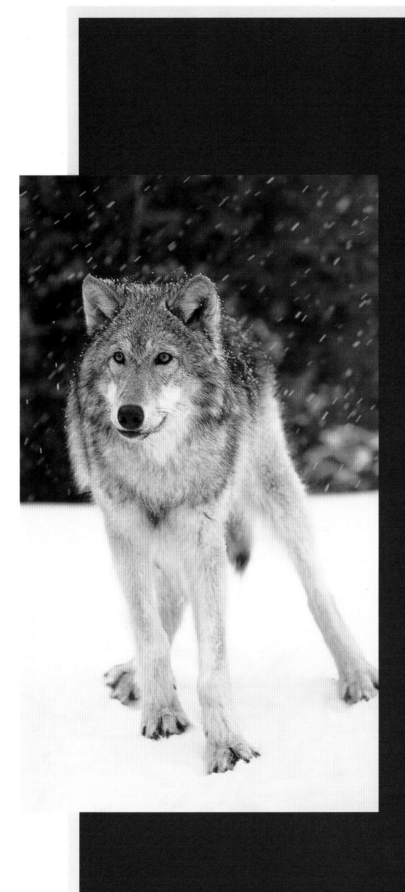

Once, millions of wolves roamed North America. During the 1800s, early settlers significantly exhausted the wild populations of deer and bison – the wolf's primary food source. In order to avoid starvation, wolves began to kill sheep and cattle.

To protect domestic livestock, government agencies launched an eradication campaign. It nearly worked. From 1883 to 1913 in Montana alone, almost 90,000 wolves were bountied by the U.S. government. By 1950, wolves had been totally eliminated from the lower 48 states, with the exception of Northern Minnesota. There are currently between 50,000 and 60,000 gray wolves in Canada and approximately 11,000 in the United States (about 7,500 in Alaska, 3,000 in the Great Lakes Area, and 300 in the Northern Rocky Mountains).

Regardless of the controversy that has surrounded the wolf for all of America's history, one thing is certain: wolves are beautiful creatures, worthy of our respect and continued research.

Hooves, Claws, and Paws

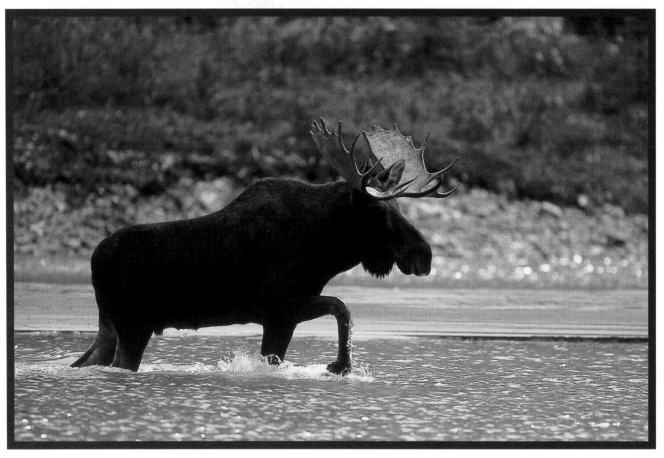

Moose

Not every wildlife species has a conservation organization working solely on its behalf, including the animals featured in this section. This does not mean, however, that these species are neglected. State and federal game and fish agencies, as well as universities, are tracking their populations and working to protect their habitats.

In addition to public and private organizations, there is a frequently forgotten, but important, group of conservationists. Hunters and farmers are often the first to notice and report wildlife problems such as disease and poaching. They are instrumental in population surveys and animal condition studies.

Other organized conservation groups, though not directly involved with a particular species, work to provide habitat for all wildlife. This mission reinforces the fact that sometimes wildlife requires very little human intervention beyond a watchful eye. More than an outpouring of human resources, many species only need protected home ranges and enough habitat to sustain them.

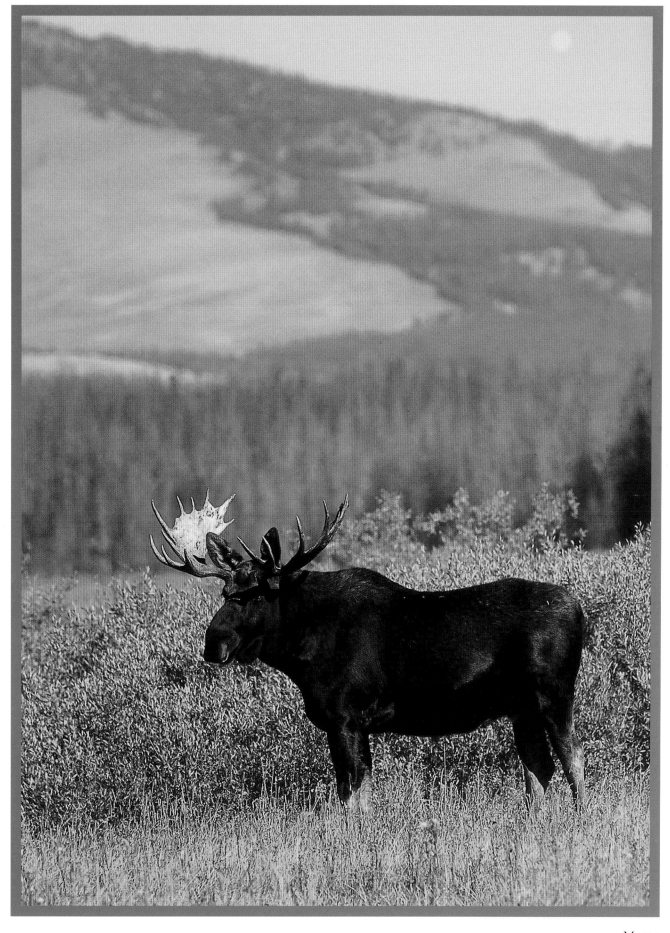

Moose

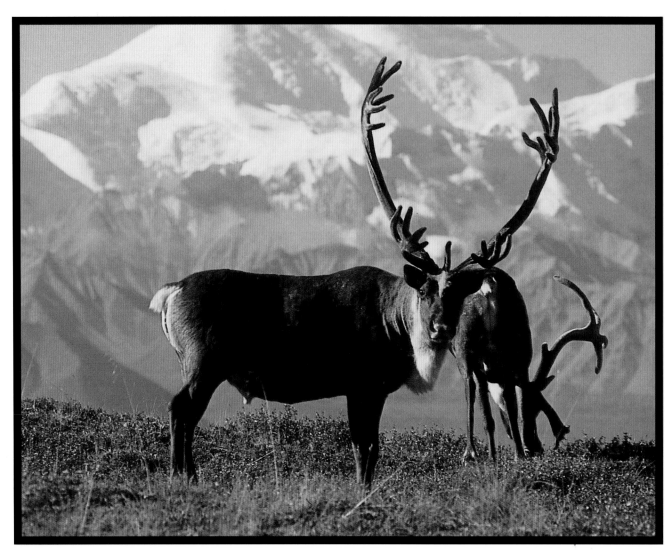

Caribou

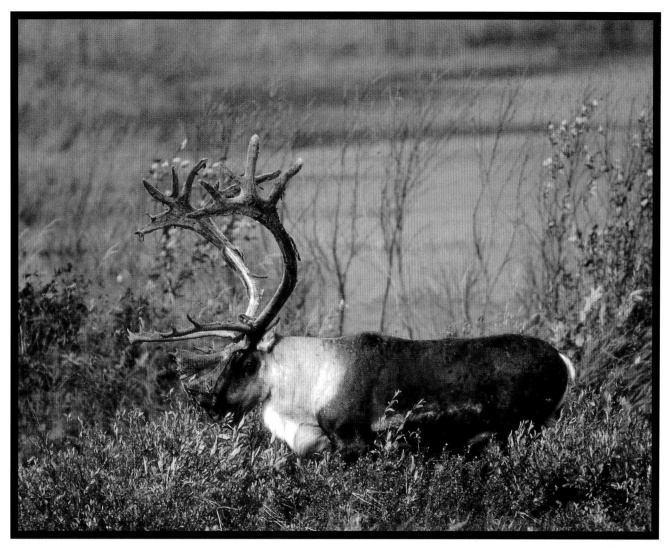

Caribou

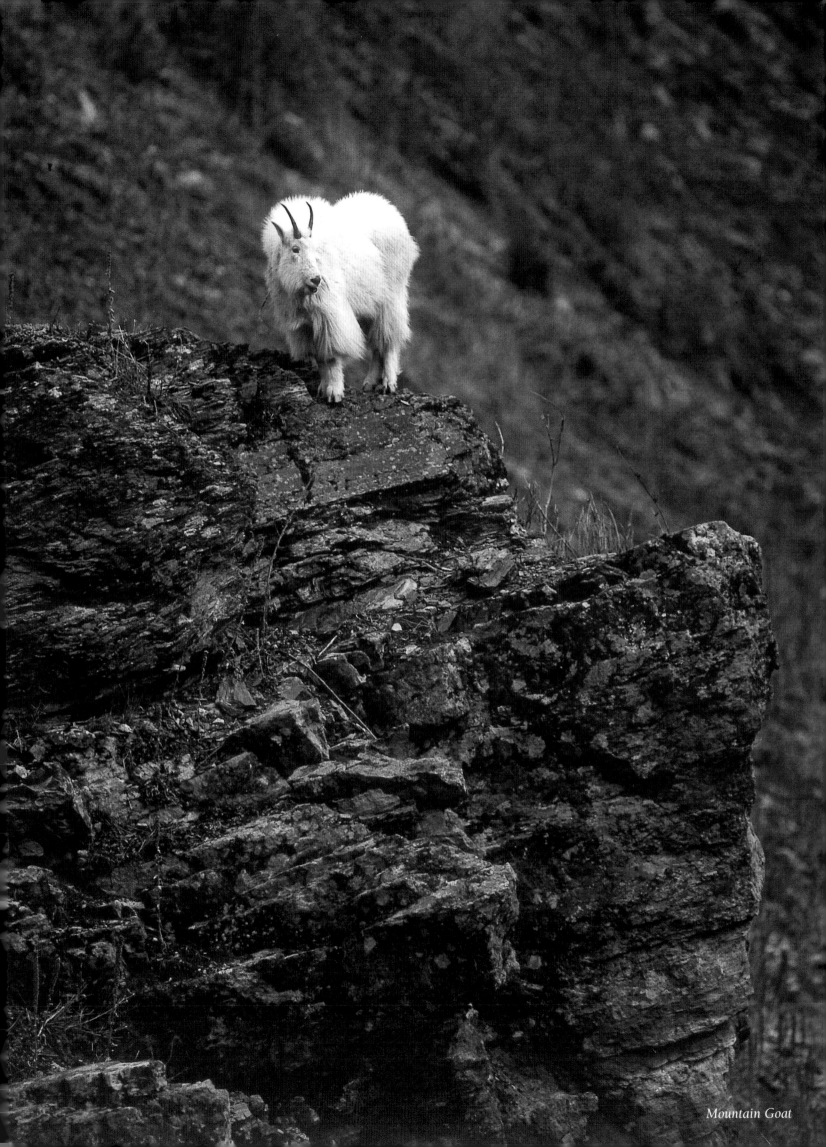

Mountain Goat

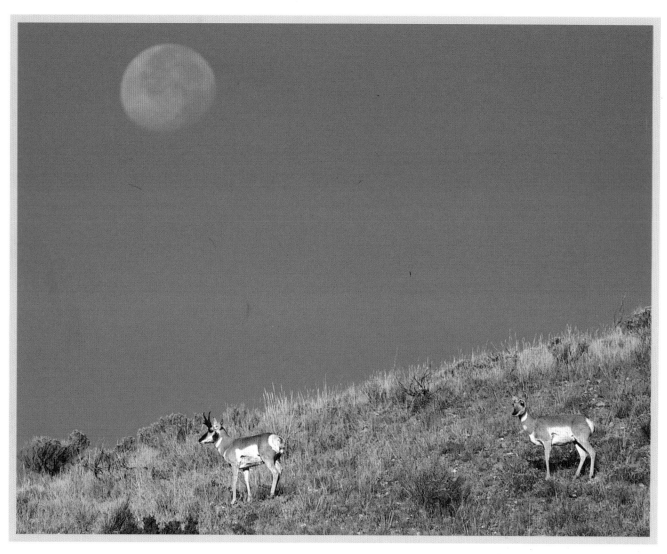

Pronghorns

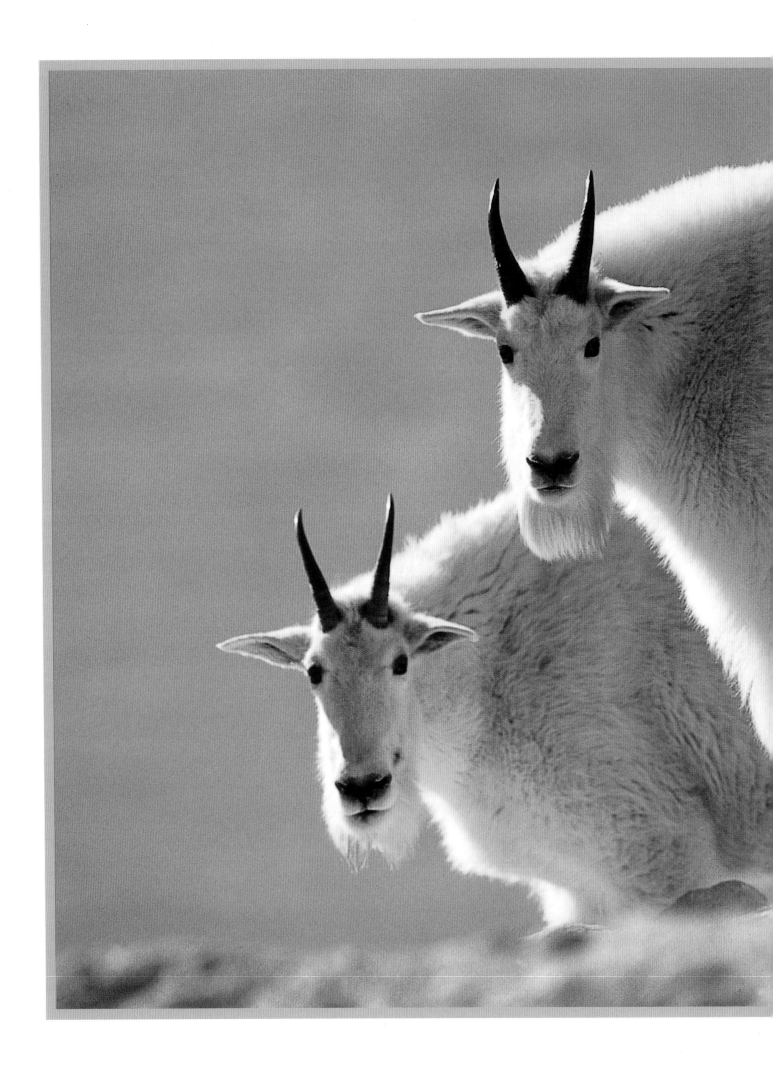

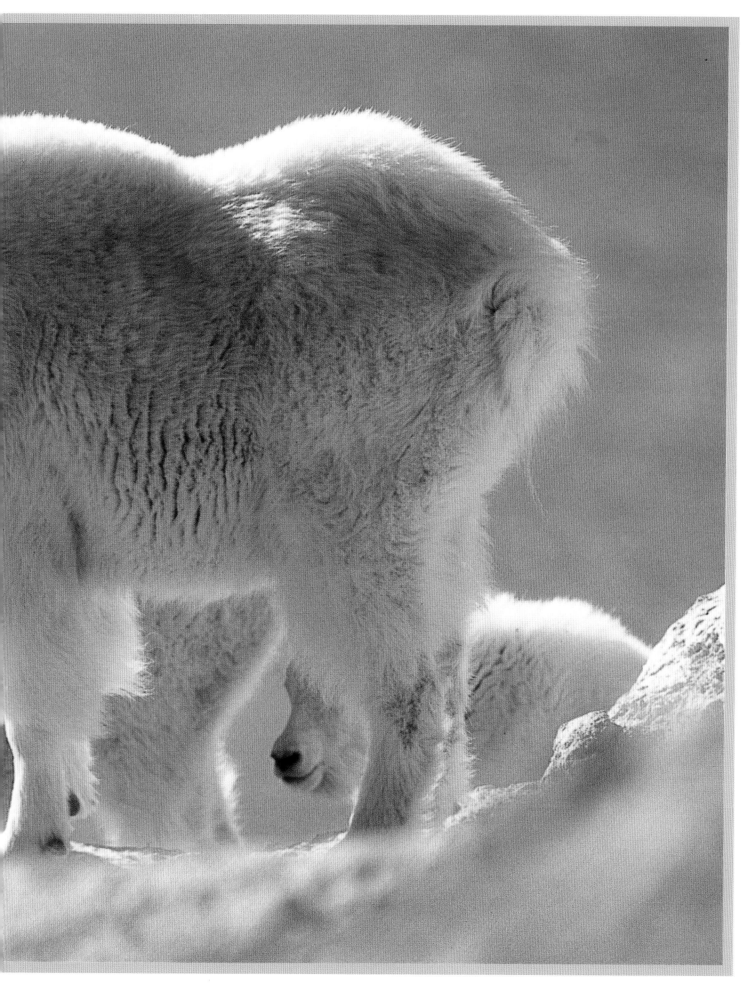

Mountain Goats

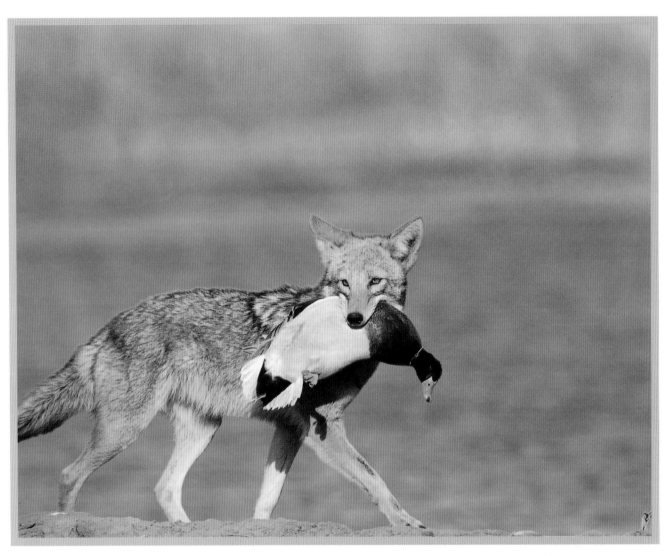

Coyote with Mallard Duck

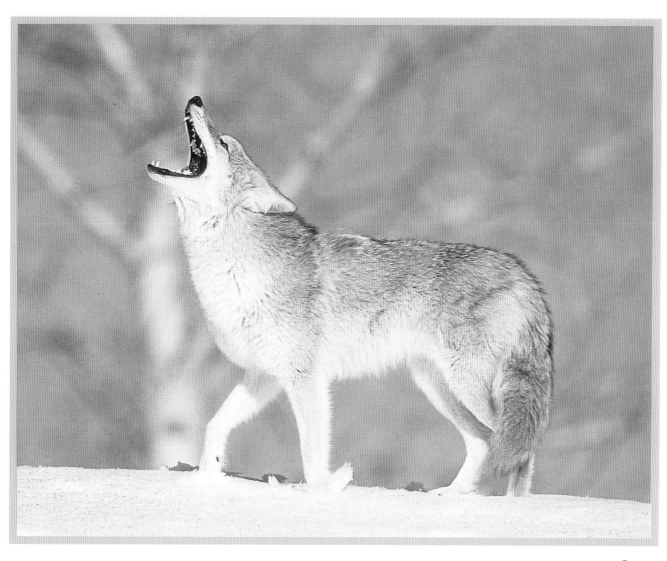

Coyote

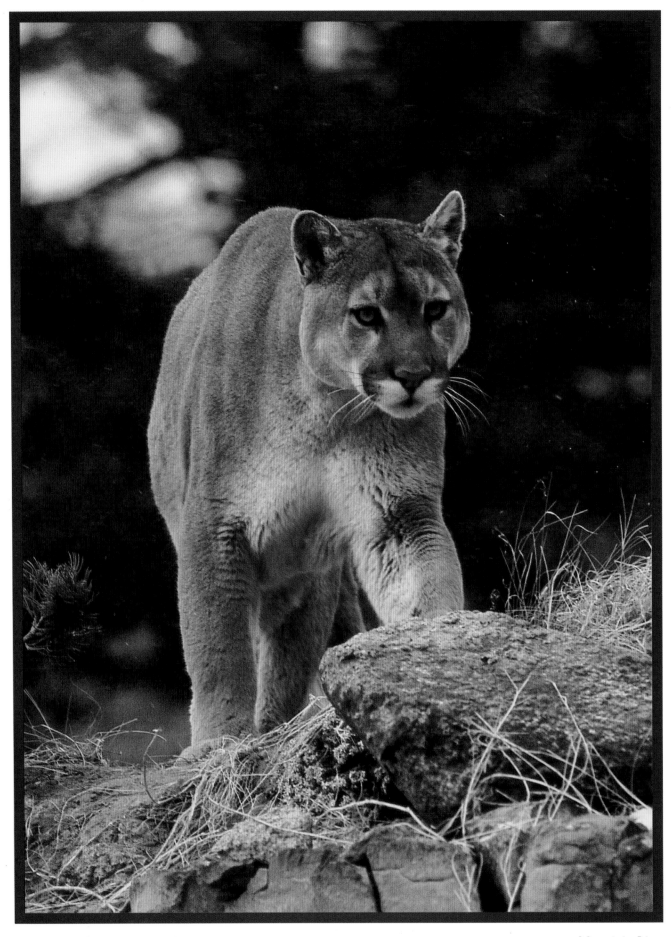

Mountain Lion

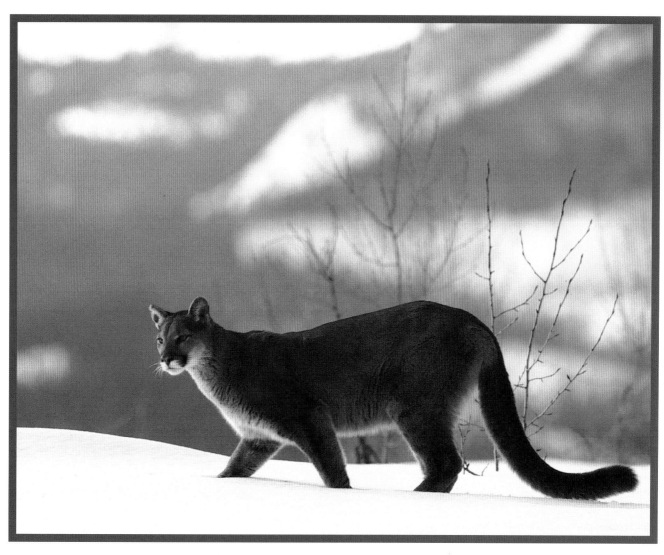

Mountain Lion

QUAIL

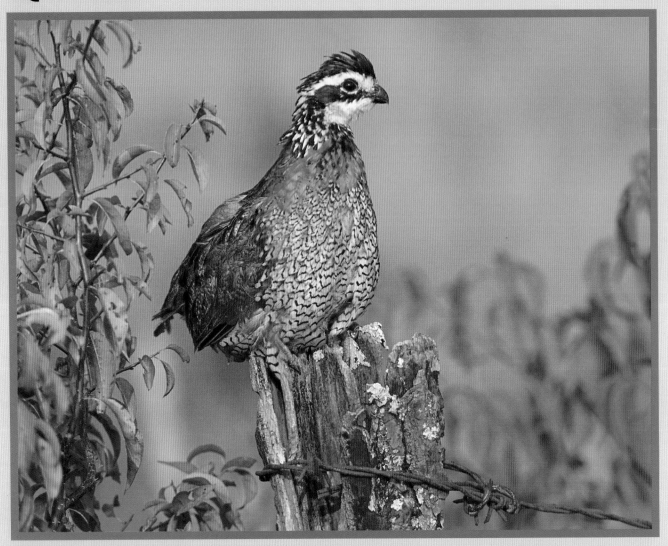

Except for a few isolated pockets, quail populations across the country have declined steadily. Bobwhite quail, the most common upland game bird, saw its numbers peak in the mid-1940s. Today their populations have fallen by more than 70 percent. This dramatic decline is a direct result of loss of habitat – food, water, and cover.

Individual landowners who develop the necessary habitat, however, are enjoying the return of large coveys. Ideal quail habitat offers a balance of bare ground, native grasses, weeds, seeds, insects, and woody cover.

Quail Unlimited (QU), established in 1981, is a nonprofit conservation organization dedicated to the wise management of America's wild quail. QU's chapter projects include habitat management, research, youth programs and informational, and educational initiatives. Aside from helping targeted wildlife species, QU's projects also benefit dove, deer, turkey, rabbits, songbirds, and other species.

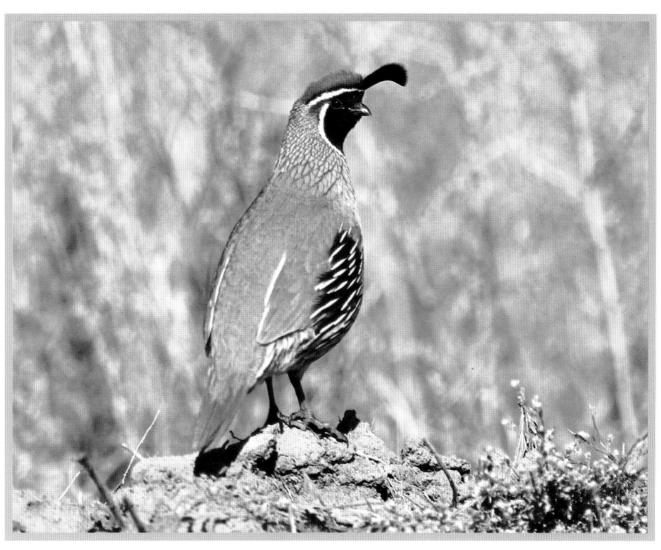

Gambel's Quail

BEARS

Grizzly or Brown Bears

Long considered the symbol of America's wilderness, the grizzly (or brown bear) once ranged across much of North America. Its territory included the Mid-Western Plains to California and Mexico to Alaska and Western Canada. As many as 100,000 grizzly bears ranged these regions as early settlers moved west. This powerful bear's numbers dwindled because of unregulated hunting and trapping and loss of habitat.

In 1975, the U.S. Fish and Wildlife Service placed the grizzly bear on the threatened species list under the Endangered Species Act. There are currently less that 1,000 grizzlies in the lower 48 states, although Alaska supports a population of approximately 30,000. Healthy populations also exist in the Canadian Rockies.

Private landowners, conservation groups, and the Interagency Grizzly Bear Committee (IGBC) are spearheading recovery efforts in the lower 48 states. Established in 1903, the IGBC is made up of the U.S. Forest Service, National Park Service, Bureau of Land Management, state agencies in Montana, Wyoming, Idaho and Washington, Canadian wildlife management agencies, and Native American Tribes.

Black Bears

Native only to North America, black bears once roamed all 12 Canadian provinces and the entire United States except Hawaii. When European settlers first arrived, there were an estimated 500,000 black bears in the United States. Today there are roughly 300,000 in the United States and about 400,000 in Canada.

While black bears in North America are not generally considered imperiled, they do face threats to their survival. Loss of habitat and poaching are the bears' greatest foes.

Black and grizzley bears often share the same habitat. However, black bears avoid areas frequented by grizzly bears, except when food supplies are abundant. When salmon make their run, black and grizzly bears are often seen fishing side by side.

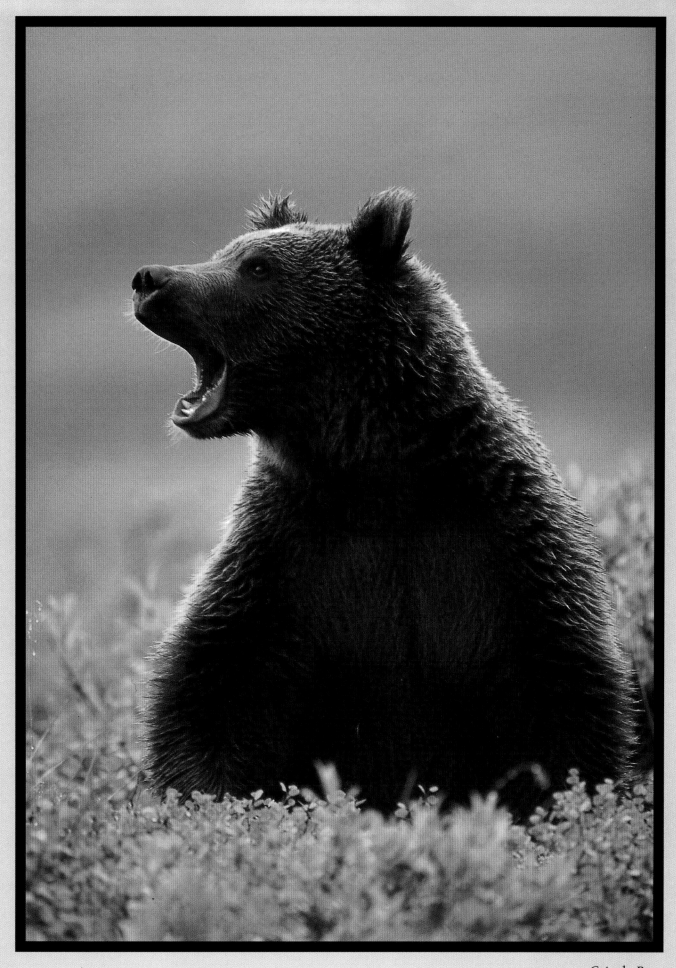

Grizzly Bear

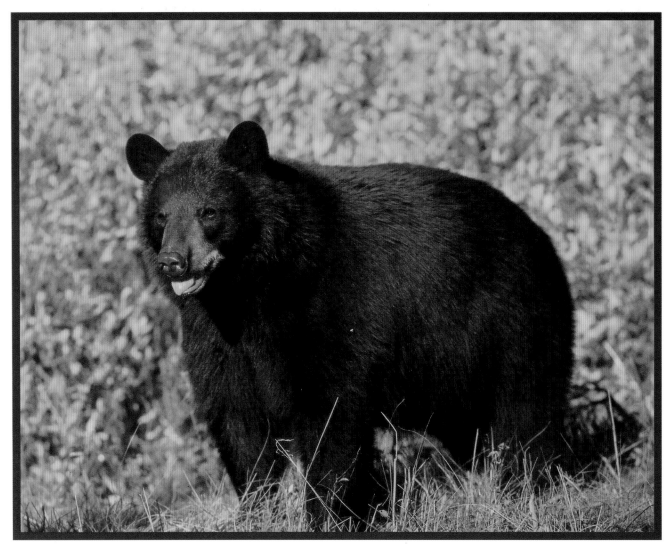

Black Bear

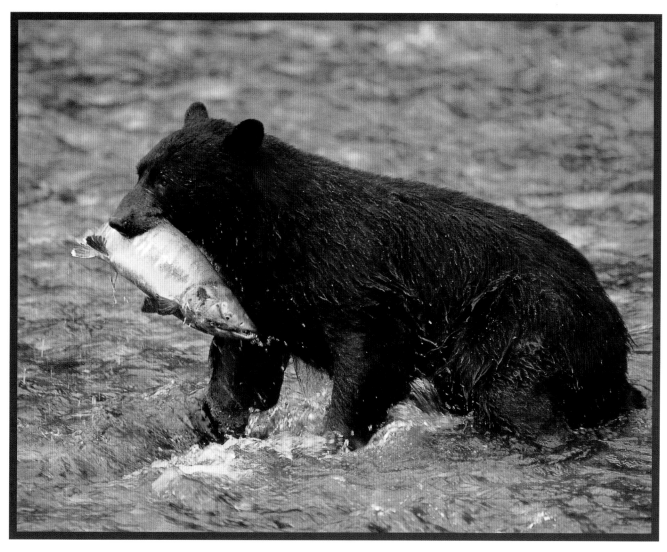

Black Bear

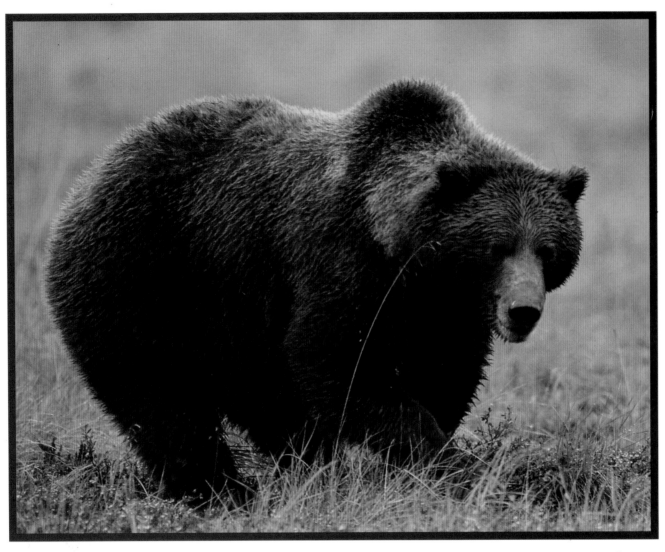

Grizzly Bear

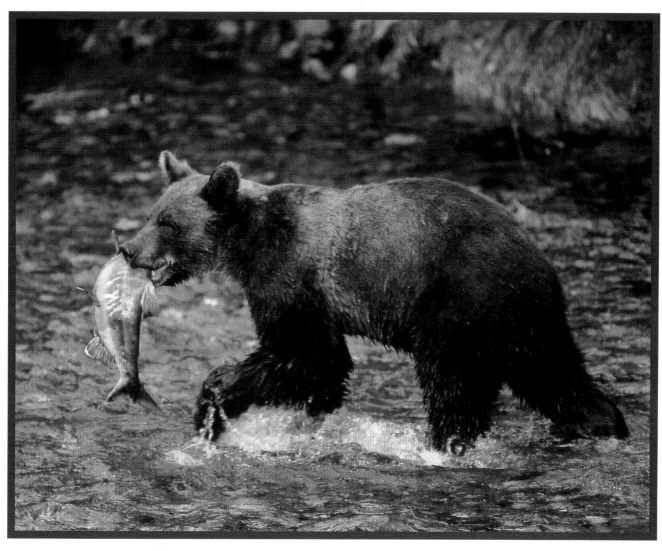

Brown Bear

Bison

Bison, or buffalo, are an icon of the American West. Roughly, 60 million bison once roamed the Great Plains. Their thundering heards represent the untamed spirit of America's early years. By the dawn of the 20th century only an estimated 1,000 bison had survived the unregulated killing during the 1800s.

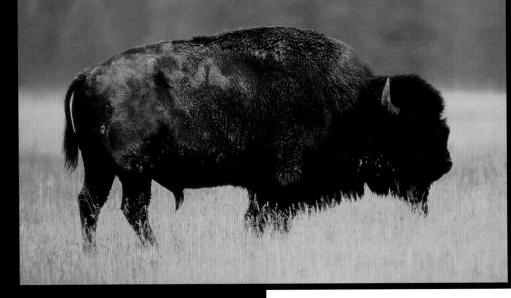

Currently only small herds of bison exist in the United Sates. They are found on privately managed ranches, Native American reservations, and in Yellowstone and Grand Teton National Parks. Today more than 200,000 free-roaming bison exist in North America.

The National Wildlife Federation, the Intertribal Bison Cooperative, and other conservation organizations are fighting to restore the bison and its habitat. Since bison are such a big part of America's history, these groups are working to ensure that bison will remain a part of America's future.

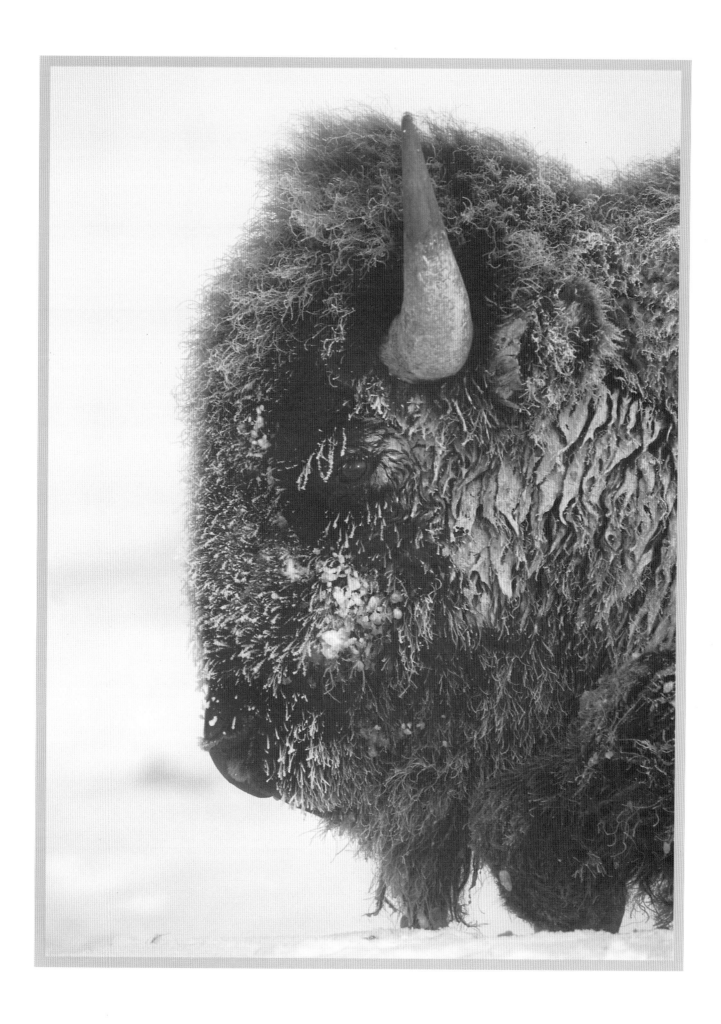

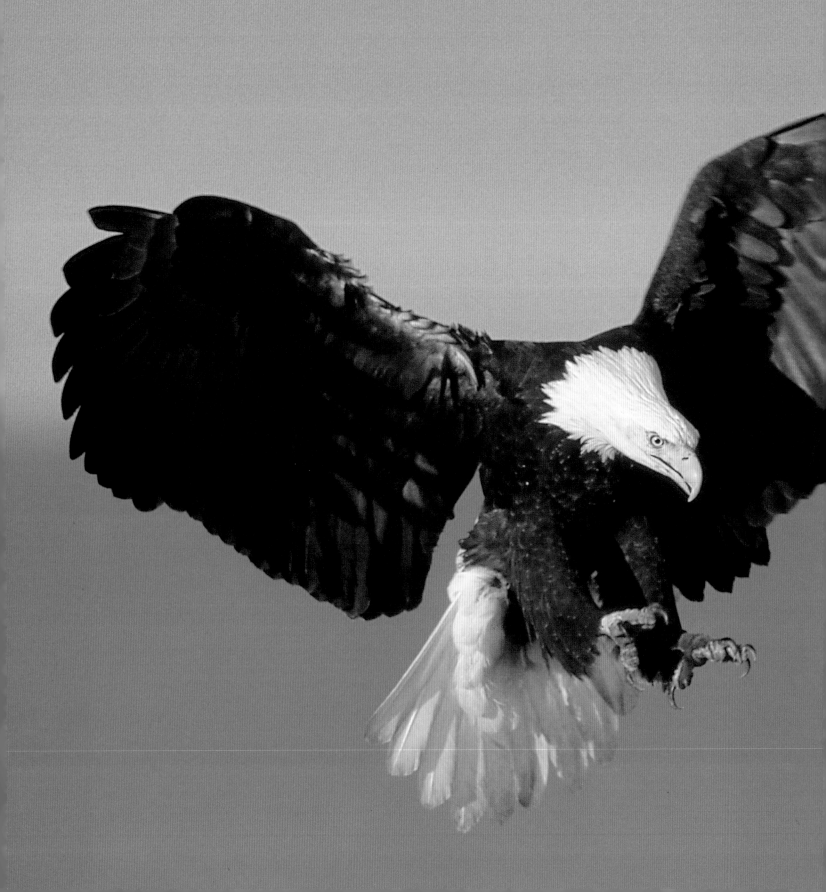

Bald Eagles

No success story rivals that of the bald eagle. Since 1782 the bald eagle has served as the proud living symbol of the United States' freedom, spirit, and determination. Its dramatic recovery from the brink of extinction is truly inspiring.

When Columbus reached America in 1492, bald eagles ranged throughout North America. In the early 1700s there was an estimated population of 300,000 to 500,000 birds. Their numbers fell to "threatened" levels in the United States of less than 10,000 nesting pairs by the 1950s and to "endangered" levels of less than 450 nesting pairs by the early 1960s.

The indiscriminate shooting of eagles, destruction of critical habitat, and the introduction of the pesticide DDT in 1947 took their toll of the stately national bird. DDT was initially used to control mosquitos in coastal and other wetland areas. It later became a widely used general insecticide. Eagles ingested DDT by eating contaminated prey which caused thinning of their egg shells. During incubation eggs often broke.

Through the efforts of many concerned and dedicated Americans and the protection provided by the "Endangered Species Act of 1972," the bald eagle is making a remarkable comeback.

The American Eagle Foundation (AEF) is a not-for-profit organization of concerned citizens and professionals founded in 1985 to develop and conduct bald eagle and environmental recovery programs in the United States and to assist private, state and federal projects that do the same.

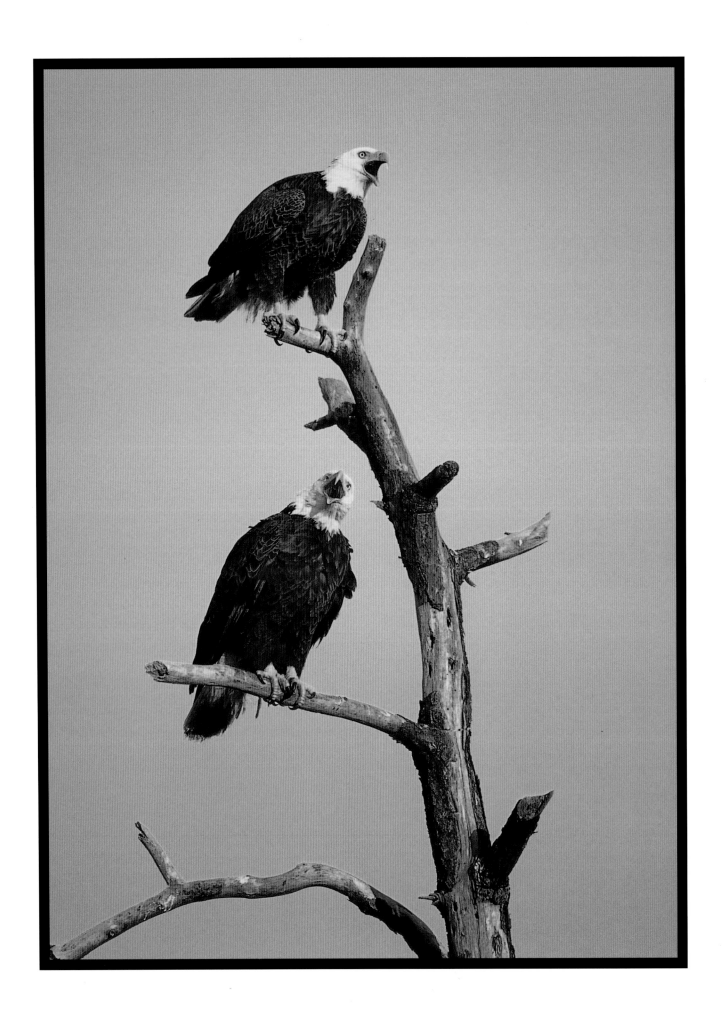

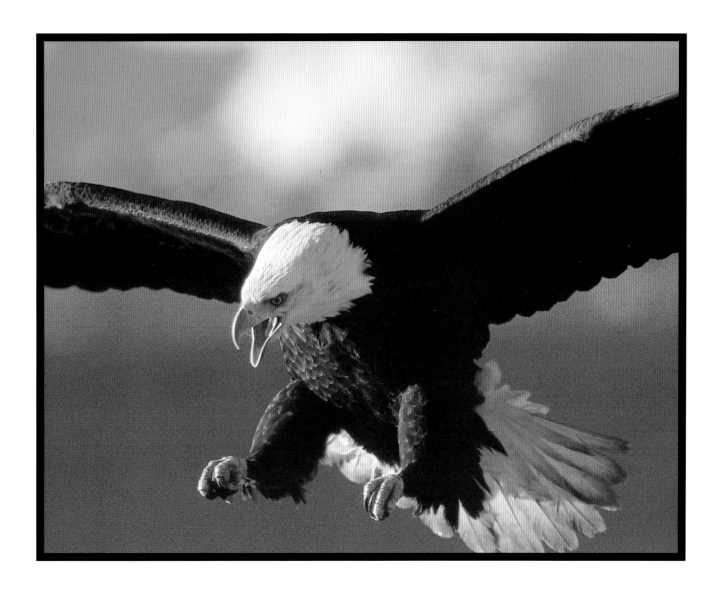

Today, there are about 6,000 nesting pairs and more than 20,000 individual birds in the lower 48 states. Bald Eagles now thrive in every state in the country, except Hawaii. Alaska alone claims over 35,000 birds.

The U.S. Fish & Wildlife Service has temporarily delayed the "de-listing" of the bald eagle from the "threatened" species list and the Endangered Species Act Protection, while government officials study other existing federal laws that safeguard eagles and their habitat.

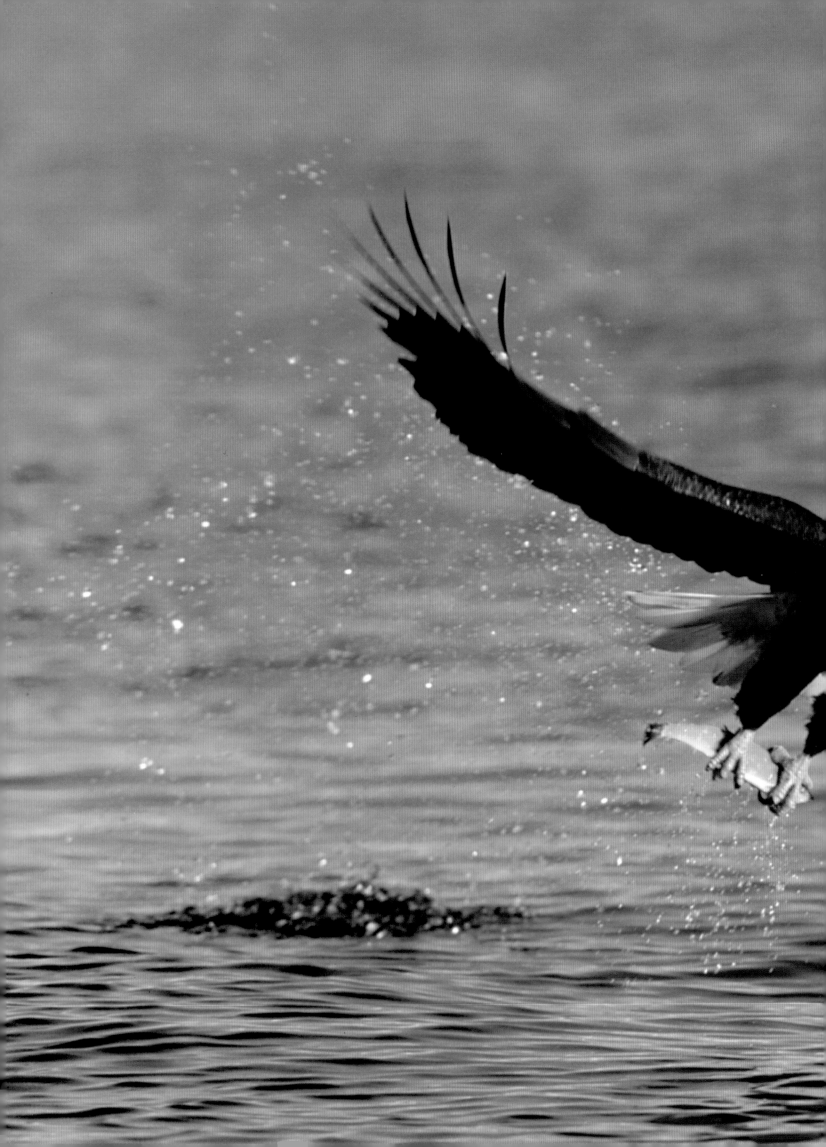

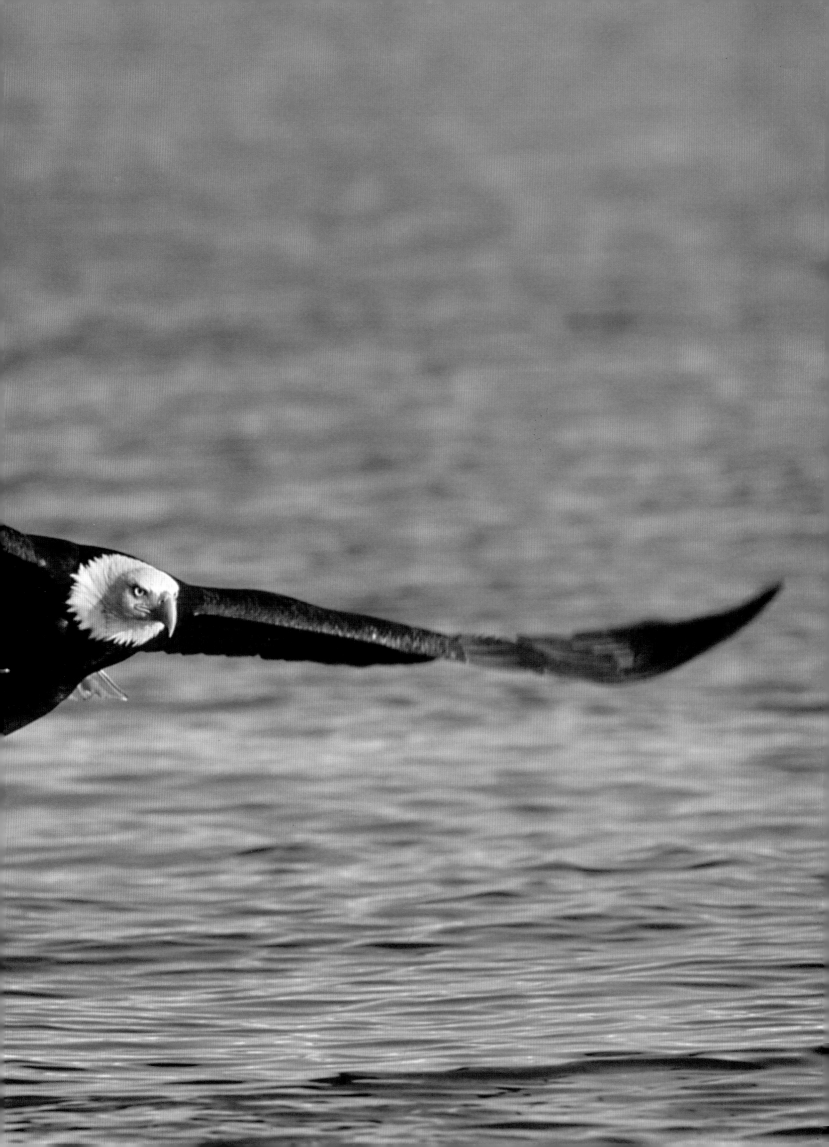

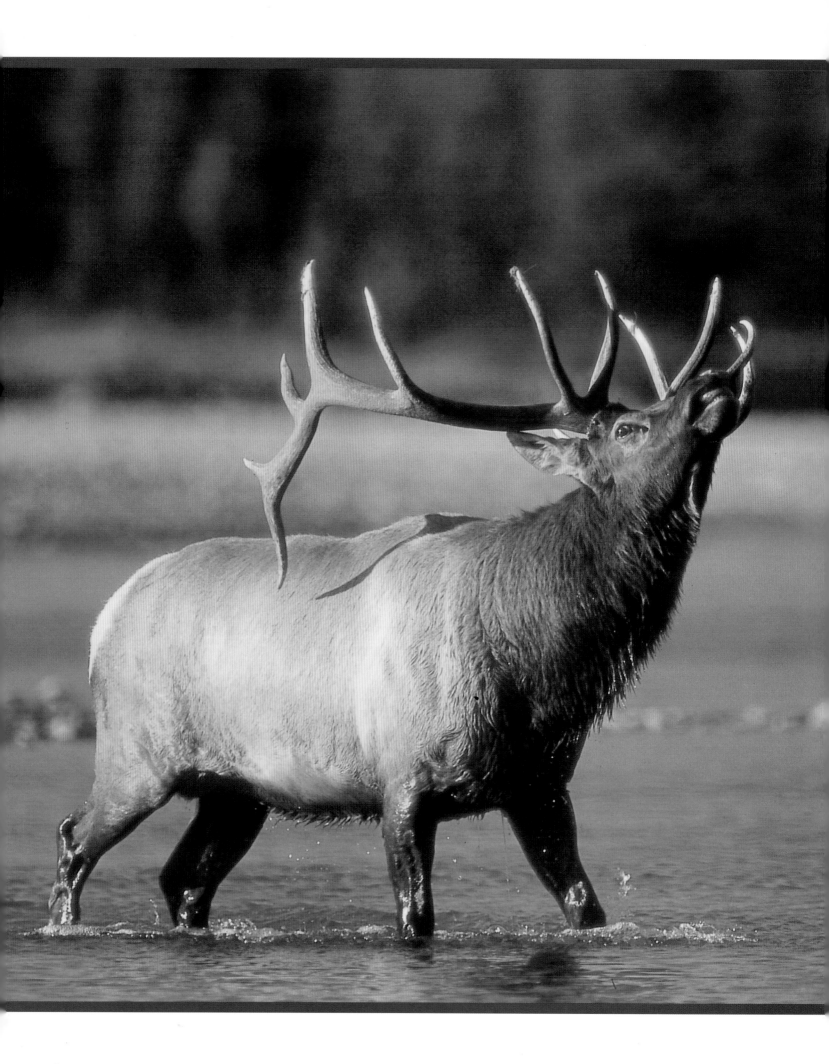

ELK

Prior to European settlement, North America was home to an estimated 10 million elk. The majestic animals roamed all across Canada and south into Mexico, and from the Pacific Coast east to the Atlantic. Only Florida and Maine have no record of wild elk within their borders. As the land was tamed, development and resource abuse reduced wildlife habitat. This loss, along with unregulated hunting, eliminated elk from much of their native range. By the late 1800s, only 10,000 elk remained.

Conservation efforts - land protection and habitat management - stabilized elk populations. Eventually populations grew enough to support regulated hunting which funded additional conservation measures. Today approximately one million elk make their home in North America, mostly in the mountainous West.

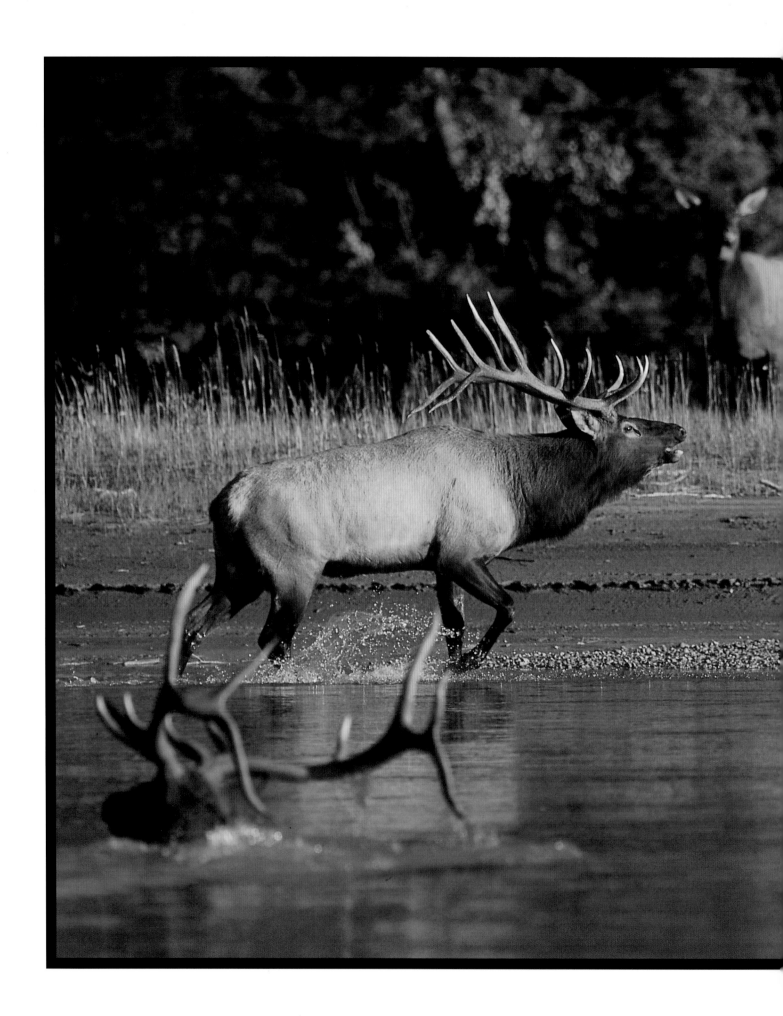

In 1984 the Rocky Mountain Elk Foundation was launched with a mission of ensuring the future of elk, other wildlife, and their habitat. The fledgling conservation organization quickly proved popular with sportsmen and others who care about wild elk and wild places. Since elk need lots of space, protecting land from uncontrolled development became a priority. In its first 18 years, with the help of many partners, volunteers, and 138,000 members, the group raised an astounding $446 million and conserved or enhanced 3.3 million acres - an area 50 percent larger than Yellowstone National Park.

In the mid-1990s the foundation also began working to restore elk to long-empty native ranges in the East. Cooperating with interested states, these efforts resulted in wild elk populations in Kentucky, Tennessee, Wisconsin, and in the Great Smoky Mountains. Remnant elk herds also began to grow in Pennsylvania, Arkansas, Michigan, Oklahoma, and other states. By the early 21st Century, elk were being observed, photographed and hunted in many areas where the species had been absent for generations.

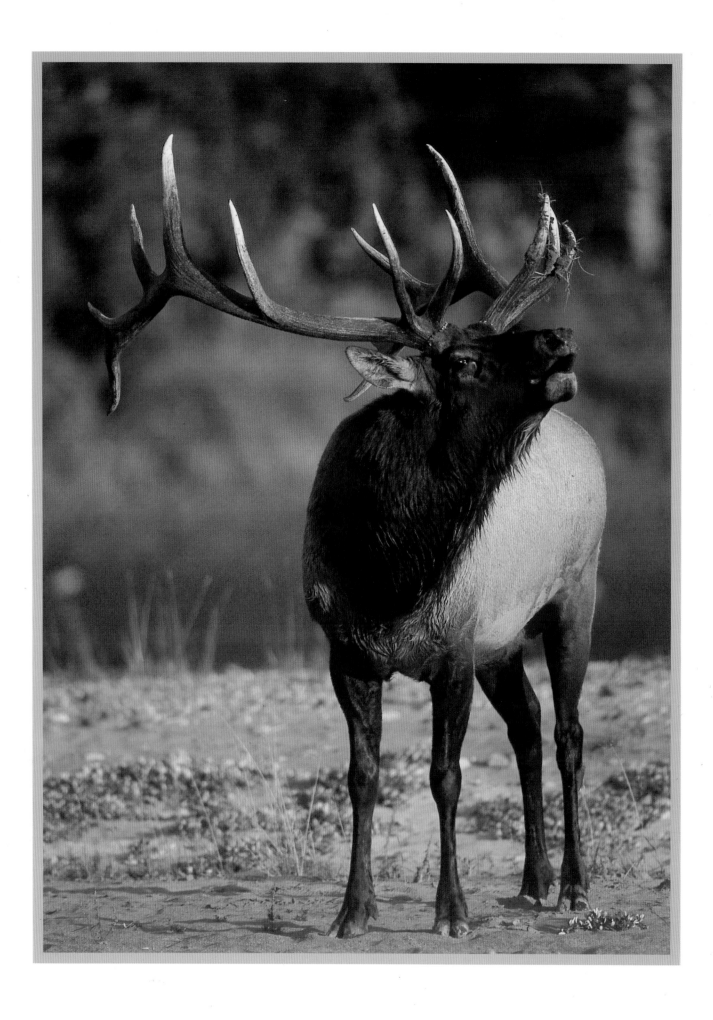

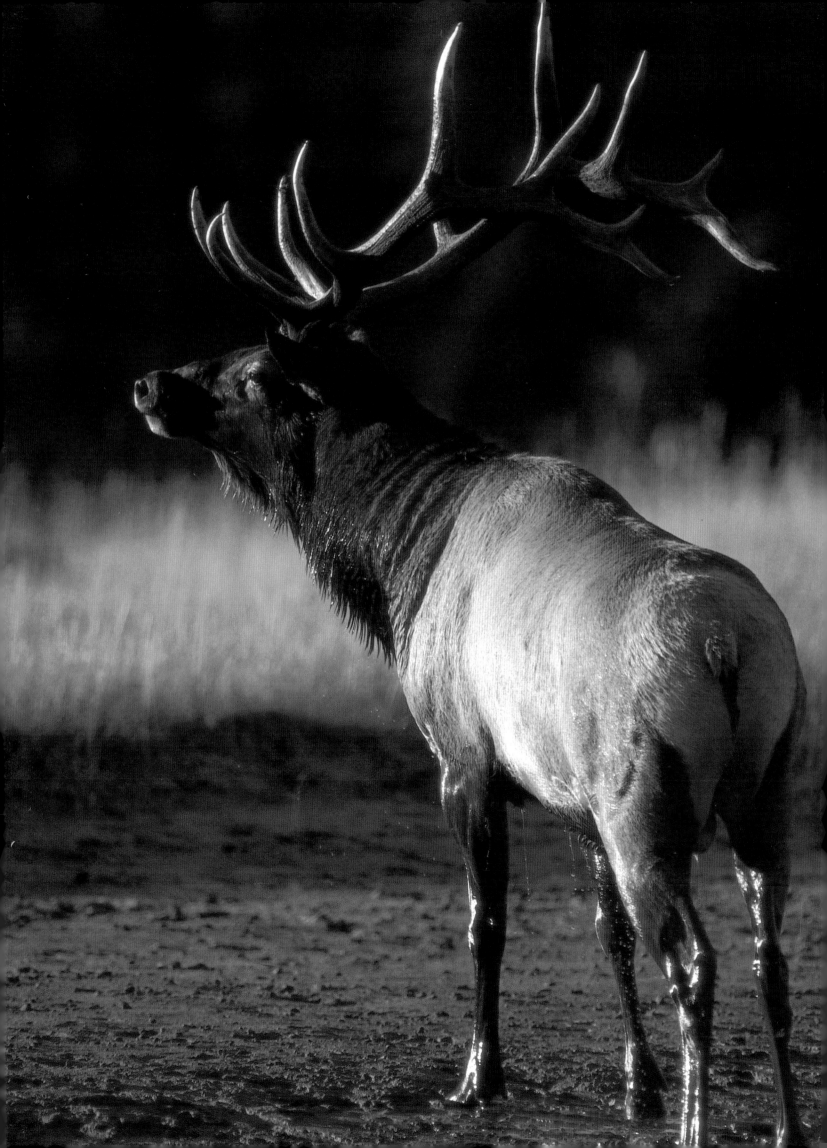

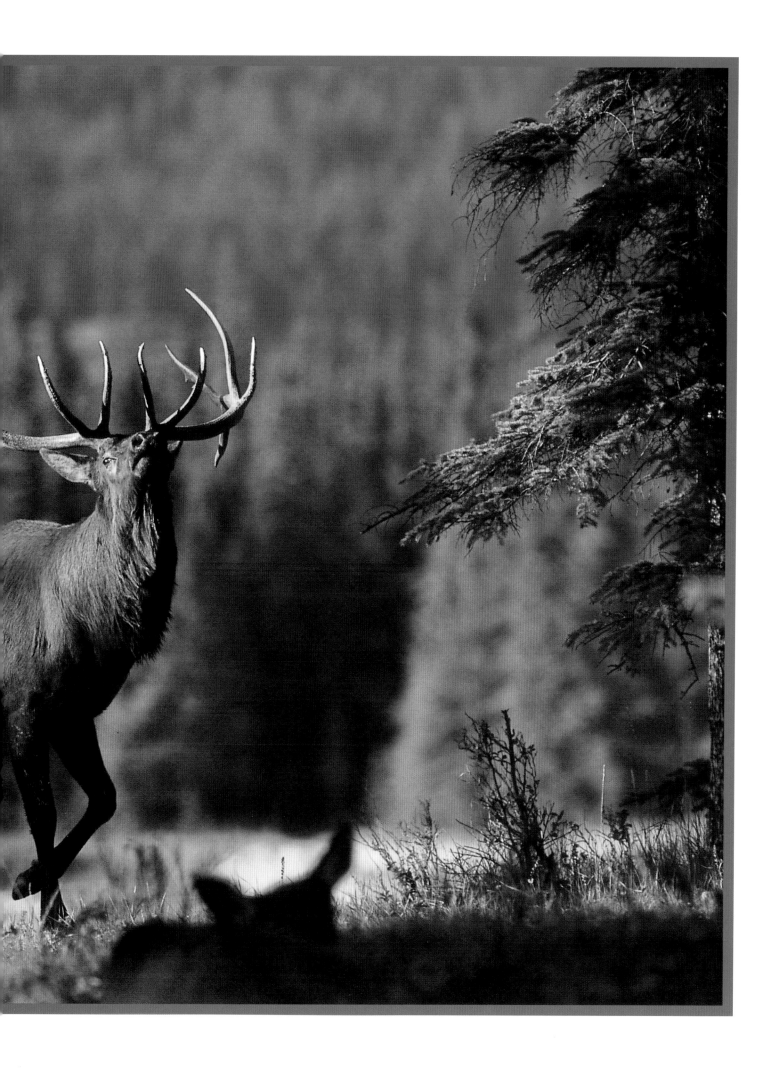

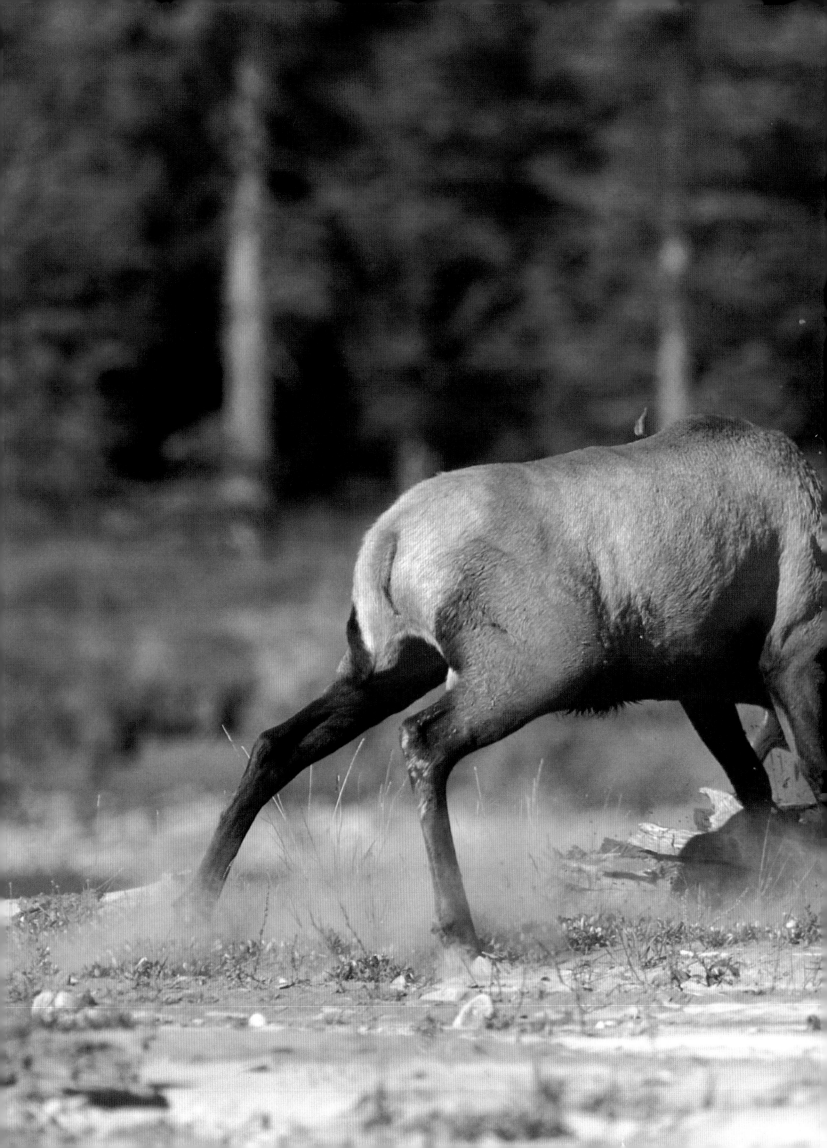

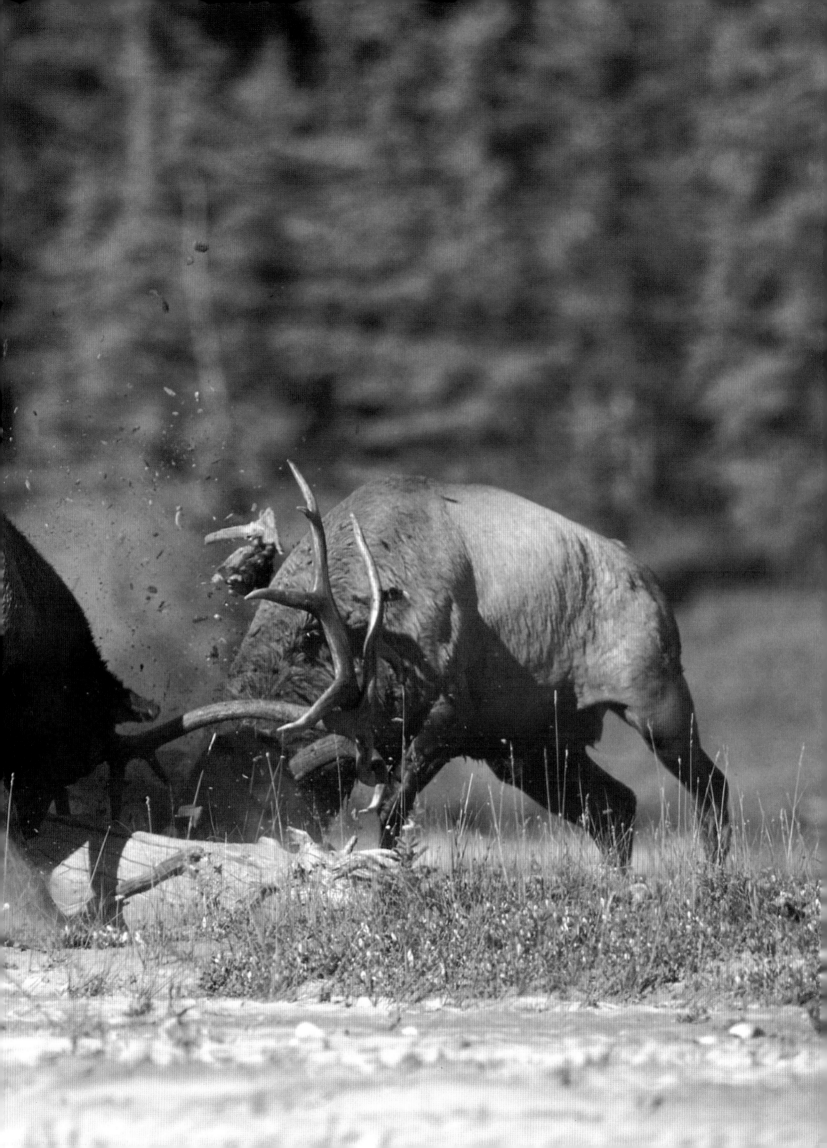

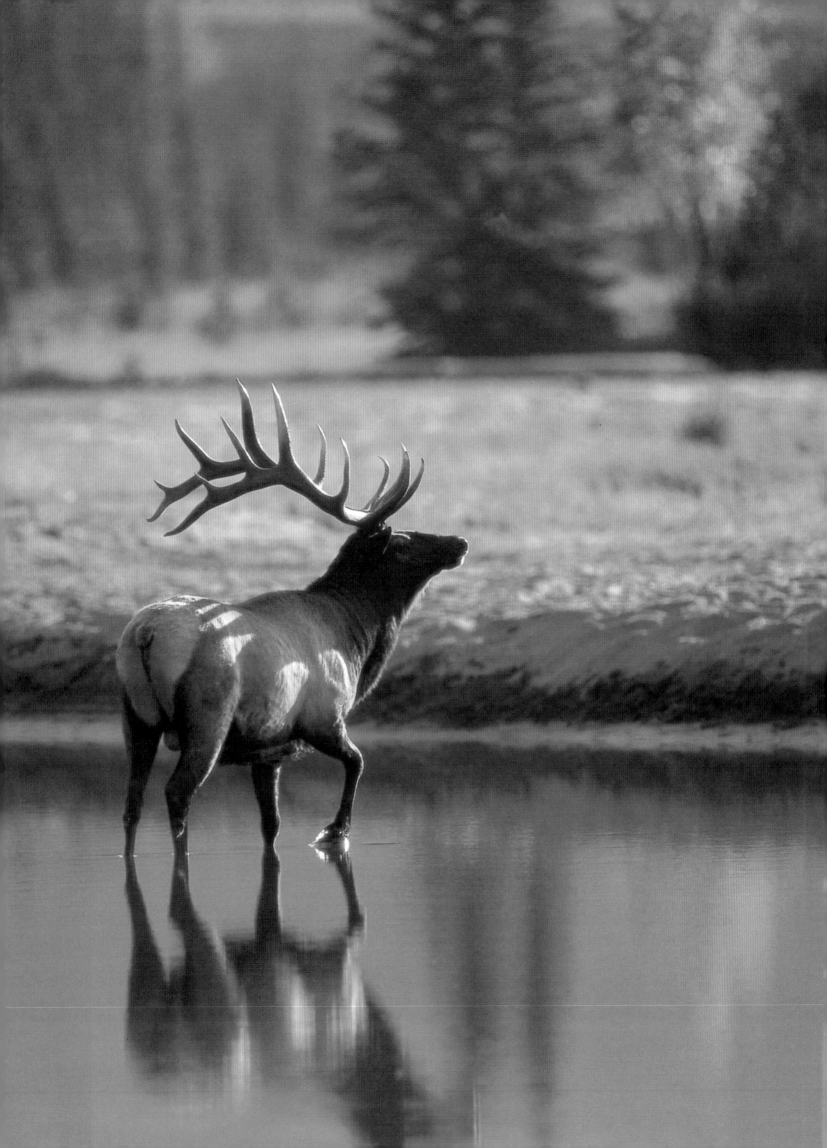

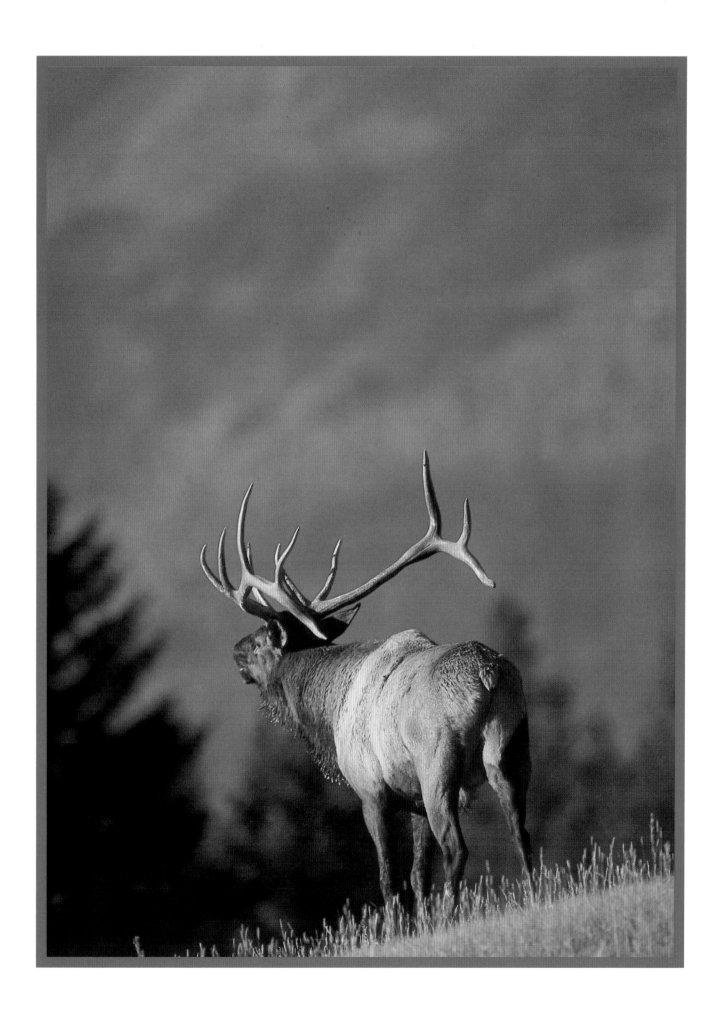

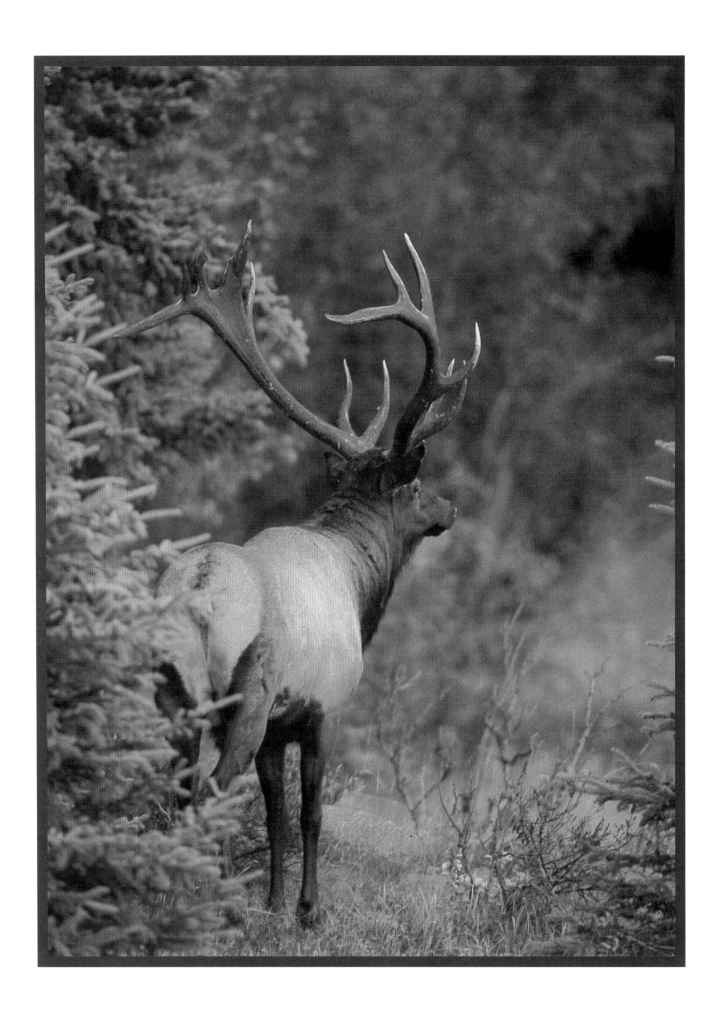

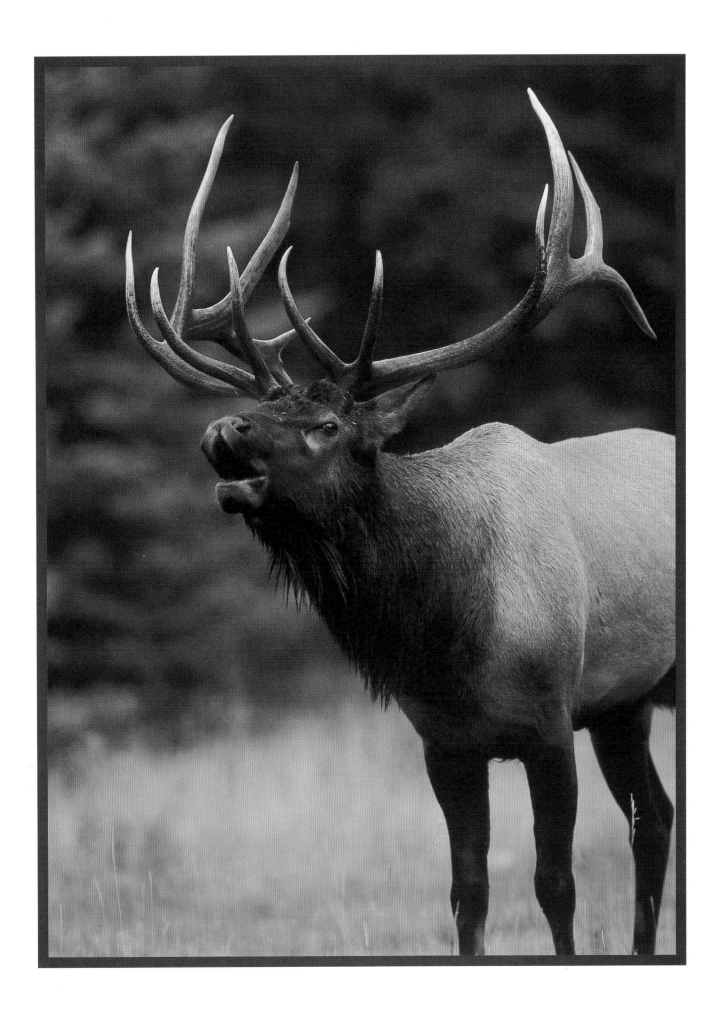

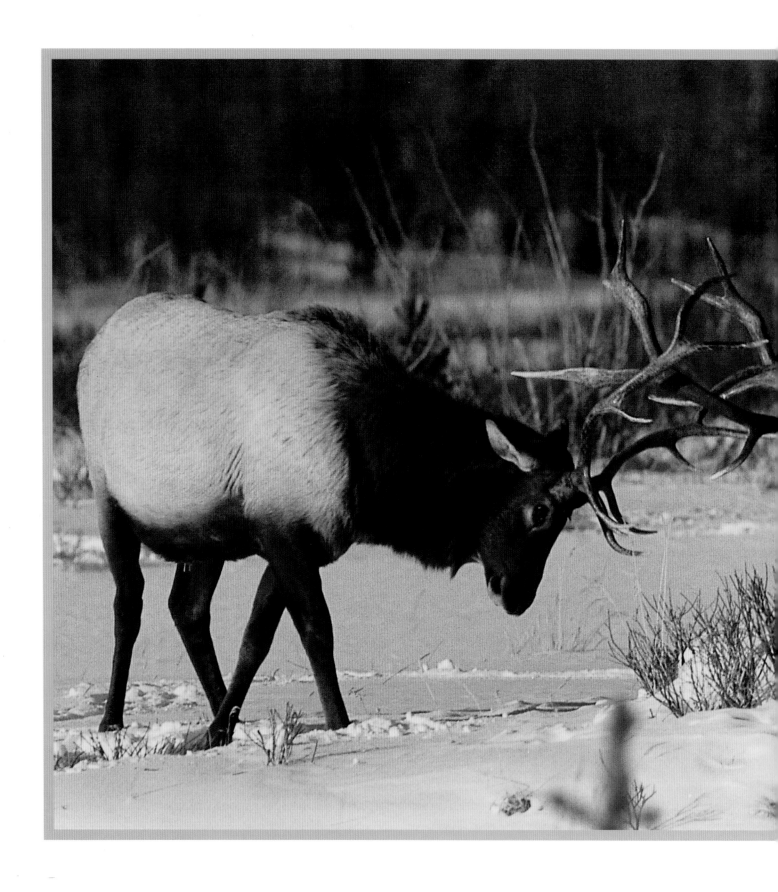

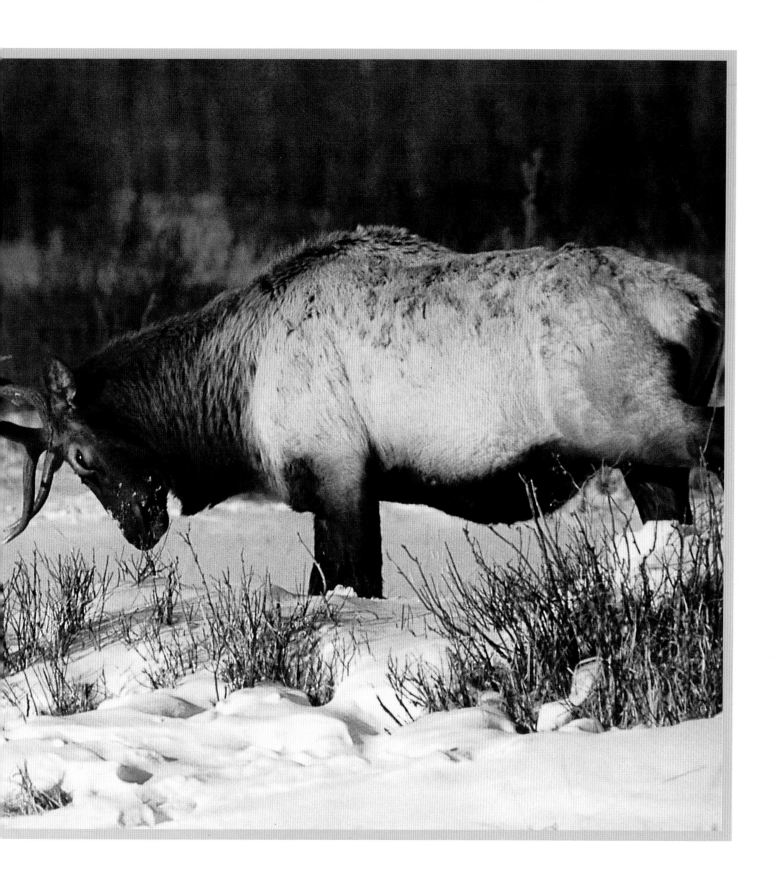

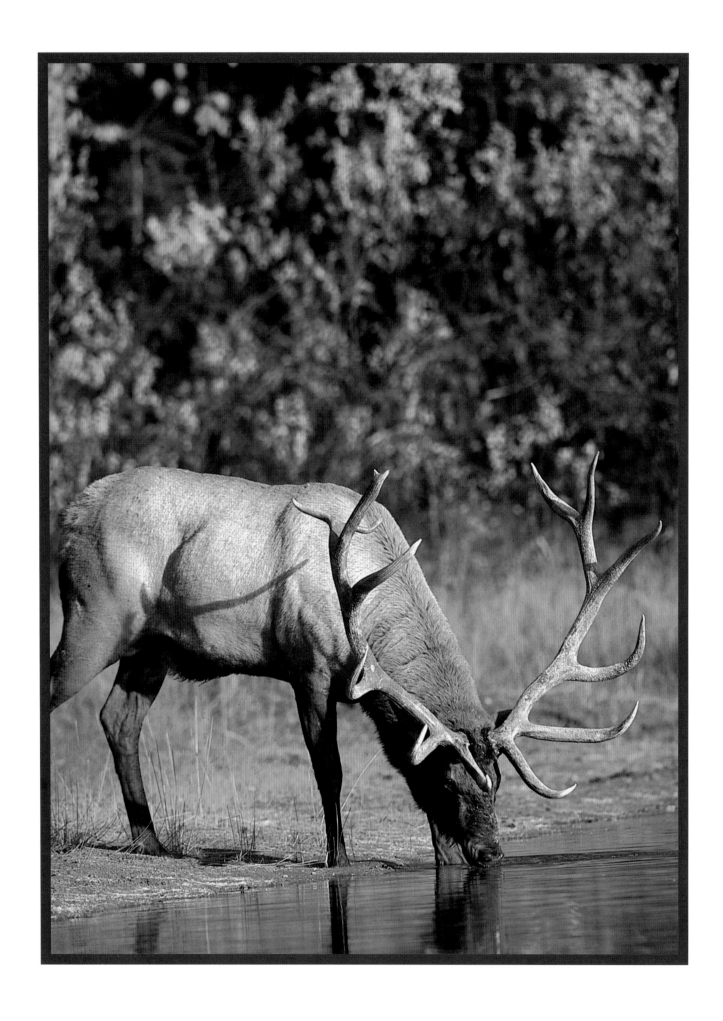

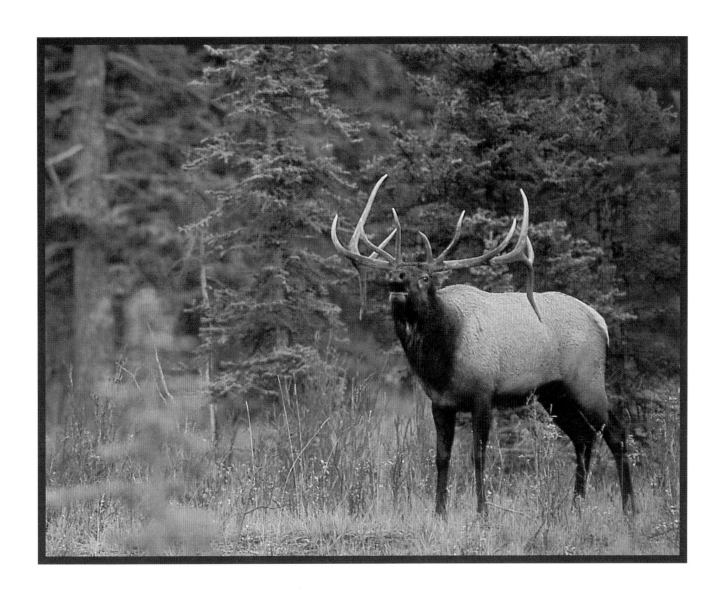

CONSERVATION ORGANIZATIONS

American Eagle Foundation
P.O. Box 333
Pigeon forge, TN 37868
(800) -2EAGLES
www.eagles.org

Delta Waterfowl Foundation
1830 N. 11th St.
P.O. Box 3128
Bismarck, North Dakota 58502
888-987-3695
www.deltawaterfowlfoundation.org

Ducks Unlimited, Inc.
One Waterfowl Way
Memphis, Tennessee 38120
1-800-45DUCKS
or 901-758-3825
www.ducks.org

Elk Foundation
P.O. Box 8249
Missoula, MT 59807
www.elkfoundation.com

Foundation for North American
Wild Sheep
720 Allen Avenue
Cody, WY 82414
(307) 527-6261
www.fnaws.org

Mule Deer Foundation
1005 Terminal Way,
Suite 170
Reno, Nevada 89502
(888) 375-DEER
www.muledeer.org

National Wild Turkey Federation
P.O. Box 530
Edgefield, SC 29824
(803) 637-3106
www.nwtf.orf

ORION-The Hunter's Institute
219 Vawter
Helena, MT 59601
(406) 449-2795
E-mail: orionhi@mt.net

Pheasants Forever
1783 Buerkle Circle
St. Paul, MN 55110
(651) 773-2000
www.pheasantsforever.org

Quail Unlimited
P.O. Box 610
Edgefield, SC 29824
(803) 637-5731
www.qu.org

Ruffed Grouse Society
451 McCormick Road
Coraopolis, PA 15108
www.ruffedgrousesociety.org

Rocky Mountain Elk Foundation
P.O.. Box 8249
Missoula, MT 59807-8249
www.elkfoundation.org

Trout Unlimited
1500 Wilson Blvd. Suite 310
Arlington, VA 22209-2404
www.tu.org

Whitetails Unlimited, Inc.
P.O. Box 720
Sturgeon Bay, WI 54235
(800) 274-5457
www.whitetailsunlimited.org

Wildlife Forever
10365 West 70th Street
Eden Prairie, MN 55344
(952) 833-1522
ww.wildlifeforever.org

National Wildlife Federation
11100 Wildlife Center Dr.
Reston, VA 20190-6085
(703) 790-6085
www.nwf.org

Intertribal Bison Cooperative
1560 Concourse Drive
Rapid City, South Dakota 57703
(605) 394-9730
www.intertribalbison.com

Quail Unlimited
31 Quail Run or P.O. Box 610
Edgefield, SC 29824
Phone: (603) 637-6731
Fax: (603) 637-0037
www.qu.org

Quality Deer Management Association
(QDMA)
Post Office Box 227
Watkinsville, GA 30677
(800) 209-DEER
www.qdma.org

National Wildlife Refuge Association
1010 Wisconsin Ave. NW Ste 200
Washington, D.C. 20007
(202) 333-9075

Save Our Wild Salmon
424 3rd. Ave. W. # 100
Seattle, WA 98119
(206) 286-4455
www.wildsalmon.org

Theodore Roosevelt Conservation
Alliance
27 Fort Missoula Rd. Ste 4
Missoula, MT 39804
(406) 549-7402
ww.trca.org

U.S. Sportsmen's Alliance,
formerly The Wildlife Legislative
Fund of America
801 Kingsmill Pkwy
Columbus, OH 43229-1137
(614) 888-4868
www.wlfa.org

The Wilderness Society
1615 M St., NW
Washington, D.C. 20036
(202) 429-2655

U.S. FEDERAL AGENCIES

U.S. Department of the Interior
1849 C Street NW
Washington, D.C. 20240
(202) 208-3171

U.S. Fish and Wildlife Service
Department of the Interior
1849 C Street NW
Washington, D.C. 20240

National Park Service
Department of the Interior
1849 C. Street NW
Washington, D.C. 20240
(202) 208-7394

Bureau of Land Management
Department of the Interior
1849 C Street NW
Washington, D.C. 20240
(202) 2051205

Burea of Land Management
Department of the Interior
1849 C Street NW
Washington, D.C. 20240
(202) 208-5717

USDA Forest Service
201 14th St., SW
Washington, D.C. 20250
(202) 205-1205

U.S. Geological Survey
Map Distribution
Federal Center
Building 14
Box 25286
Denver, CO 80225

DEPARTMENTS OF GAME AND FISH UNITED STATES

Alabama Department of Conservation
and Natural Resources
64 N. Union St.
Montgomery, AL 36130-1456
(334) 242-3465

Alaska Department of Fish and Game
P.O. Box 25526
Juneau, AK 99802-5526
(907) 465-5999

Arizona Game and Fish Department
2222 W. Greenway Road
Phoenix, AZ 85023
(602) 942-3000

Arkansas Game and Fish Commission
#2 Natural Resources Drive
Little Rock, AR 72205
1-800-364-GAME

California Department of
Fish and Game
3211 South Street
Sacramento, CA 95814
(916) 227-2271

Colorado Department of
Natural Resources
6060 Broadway
Denver, CO 80216
(303) 297-1192

Connecticut Department of
Environmental Protection
79 Elm Street
Wildlife Division
Hartford, CT 06106-5127
(860) 424-3011

Delaware Division of Fish & Wildlife
89 Kings Highway
P.O. Box 1401
Dover, DE 19903
(302) 739-4431

Florida Fish and Wildlife
Conservation Commission
Route. 7 Box 440
Lake City, FL 32055
(904) 758-0525

Georgia Wildlife Resources Division
2123 US Highway 278
Social Circle, GA 30025
(770) 918-6418

Hawaii Division of Forestry & Wildlife
1151 Punchbowl Street
Honolulu, HI 96813
(808) 548-4000

Idaho Fish and Game Department
600 South Walnut Street
P.O. Box 25
Boise, ID 83707
(208) 334-3700

Illinois Department of
Natural Resources
524 S. Second Street
Springfield, IL 62701
(217) 782-6302

Indiana Division of Fish & Wildlife
402 W. Washington Street
Indianapolis, IN 46204
(317) 232-4080

Iowa Division Department of
Natural Resources
Wallace State Office Building
E. Ninth and Grand Ave.
Des Moines, IA 50319
(515) 281-4367

Kansas Department of Wildlife & Parks
512 SE 25th Avenue
Pratt, KS 67124-8174
(316) 672-5911

Kentucky Department of Fish and
Wildlife Resources
1 Game Farm Road
Frankfort, KY 40601
(502) 564-3400

Louisiana Department of
Wildlife and Fisheries
P.O. Box 98000
Baton Rouge, LA 70898-9000
(504) 765-2800

Maine Department of Inland Fisheries
and Wildlife
284 State Street Station, 41 State House
Station
Augusta, ME 04333
(207)287-8000

Maryland Department of
Natural Resources
Tawes State Office Building
580 Taylor Avenue
Annapolis, MD 21401
(301) 974-3990

Massachusetts Department of Fisheries,
Wildlife and Environmental Law
Enforcement
251 Causeway St., Suite 400
Boston, MA 02114-2104
(617) 727-1614

Michigan Department of
Natural Resources
P.O. Box 30444
Lansing, MI 48909
(517) 373-6705

Minnesota Department of
Natural Resources
Division of Fish and Wildlife
500 Lafayette Road
St. Paul, MN 55155-4001
(612) 296-6157

Mississippi Department of Wildlife,
Fisheries, and Parks
1505 Eastover Dr.
Jackson, MS 39211-6374
(601) 432-2400

Missouri Department of Conservation
2901 West Truman Blvd.
Jefferson City, MO 6109
(573) 751-4115

Montana Fish, Wildlife and Parks
1420 E. Sixth
Helena, MT 59620
(406) 444-2535

Nebraska Game and Parks Commission
2200 N. 33rd Street
Lincoln, NE 68503
(402) 471-0641

Nevada Department of Wildlife
1100 Valley Road
Reno, NV 89512
Phone (775)688-1500

New Hampshire Fish and Game
Department
2 Hazen Drive
Concord, NH 03301
(603) 271-3211

New Jersey Division of Fish, Game and
Wildlife
P.O. Box 400
Trenton, NJ 08625-0400
(609) 292-2965

New Mexico Game and Fish
Department
PO Box 25112
Santa Fe, NM 87504
(505) 476-8116

New York State Department of
Environmental Conservation
625 Broadway
Albany, NY 12233
(518) 402-8924

North Carolina Department of
Environment and Natural Resources
1722 Mail Service Center
Raleigh, NC 27699
(919) 733-7291

North Dakota State Game and Fish
Department
100 N. Bismark Expressway
Bismark, ND 58501-5095
(701)328-6300

Ohio Division of Wildlife
1840 Belcher Drive
Columbus, OH 432248
(614) 265-6300

Oklahoma Department of
Wildlife Conservation
P.O. Box 53465
1801 N. Lincoln
Oklahoma City, OK 73105
(405) 521-3856

Oregon Department of
Fish and Wildlife
P.O. Box 59
Portland, OR 97207
(503) 872-5268

Pennsylvania Game
201 Elmerton Avenue
Harrisburg, PA 17110-9797
(717) 787-2869

Rhode Island Department of
Environmental Management
235 Promenade Street
Providence, RI 02908
(401) 277-2774

South Carolina Department of
Natural Resources
Department of Game & Fish
P.O. Box 167
Columbia, SC 29202
(803) 734-3888

South Dakota Game, Fish and Parks
523 East Capitol Avenue
Pierre, SD 57501-3182
(605) 773-3391

Tennessee Wildlife Resources Agency
Ellington Agricultural Center
P.O. Box 40747
Nashville, TN 37204
(615) 781-6500

Texas Parks and Wildlife
4200 Smith School Road
Austin, TX 78744
(512) 389-4800

Utah Division of Wildlife Resources
1594 W. North Temple
Salt Lake City, UT 84114
(801) 538-7200

Vermont Fish and Wildlife
Department
103 S. Main Street
Waterbury, VT 05671-0501
(802) 241-3701

Virginia Department of Game and
Inland Fisheries
4010 W. Broad Street
Richmond, VA 23230
(804) 367-1000

Washington Department of
Fish and Wildlife
600 Capitol Way N.
Olympia, WA 98501-1091
(360) 902-2200

West Virginia Department of
Natural Resources
State Capitol Complex, Building 3
1900 Kanawha Boulevard E.
Charleston, WV 25305
(304) 558-2771

Wisconsin Department of
Natural Resources
P.O. Box 7921
Madison, WI 53707
(608) 266-2621

Wyoming Game and Fish Department
5400 Bishop Boulevard
Cheyenne, WY 82006
(307) 777-4600

CANADA

Alberta Sustainable Resource
Development
Fish and Wildlife Division
Main Floor, South Tower,
Petroleum Plaza
9915 108th Street
Edmonton, Alberta, Canada T5K 2G6
(403) 427-5185

British Columbia Ministry of the
Environment, Lands & Parks
Wildlife Branch, 4th Floor
2975 Jutland Rd.
Victoria, British Columbia, Canada
V8T5J9
(150) 387-9717

Manitoba Conservation
Wildlife Branch
Box 24, 200 Saulteaux Crescent
Winnipeg, Manitoba, Canada R3J 3W3
(800) 214-6497

New Brunswick Department of
Natural Resources
Fish & Wildlife Branch
P.O. Box 6000
Frediricton, New Brunswic, Canada
E3B 5HI
(506) 453-2440

Newfoundland and Labrador Forest
Resources & Agrifoods
Wildlife Headquarters
Bldg. #810 Pleasantville
St. John's Newfoundland, Canada
AIB 4J6
(709) 729-2817

Prince Edward Island Fish & Wildlife
Department of Fisheries, Agriculture
and Environment
P.O. Box 2000
11 Kent Street
Charlottetown, Prince Edward Island,
Canada C1A 7N8
(902) 368-5830

Ontario Natural Resources
Information Center
1st Floor
P.O. Box 7000
300 Walter Street
Peterborough, Ontario, Canada 89J 8M5
(705) 755-1677

Nova Scotia Department of
Natural Resources
P.O. Box 698
Halifax, Nova Scotia, Canada B3J 2T9
(902) 424-7735

Quebec Department of Recreation
Fish & Wildlife Division
150 Rene Levesque E. 4th Floor
quebec city, Quebec, Canada GIR 4Y1
(418) 842-0318

Saskatchewan Environment
and Resource
Management Wildlife Branch
3211 Albert St. Rm. 436
Regina, Saskatchewan, Canada S4S 5W6
(306) 787-2314

Yukon Department of
Renewable Resources
P.O. Box 2703
Whitehorse, Yukon, Canada Y1A 2C6
(867) 667-5652

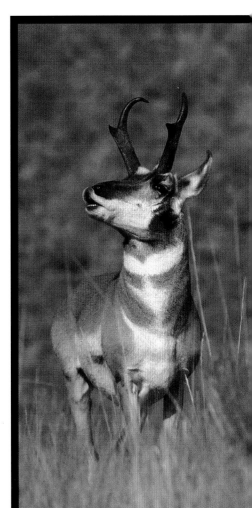

"In the end we will conserve only what we love, we will love only what we understand, and we will understand only what we have been taught."

Baba Dioum

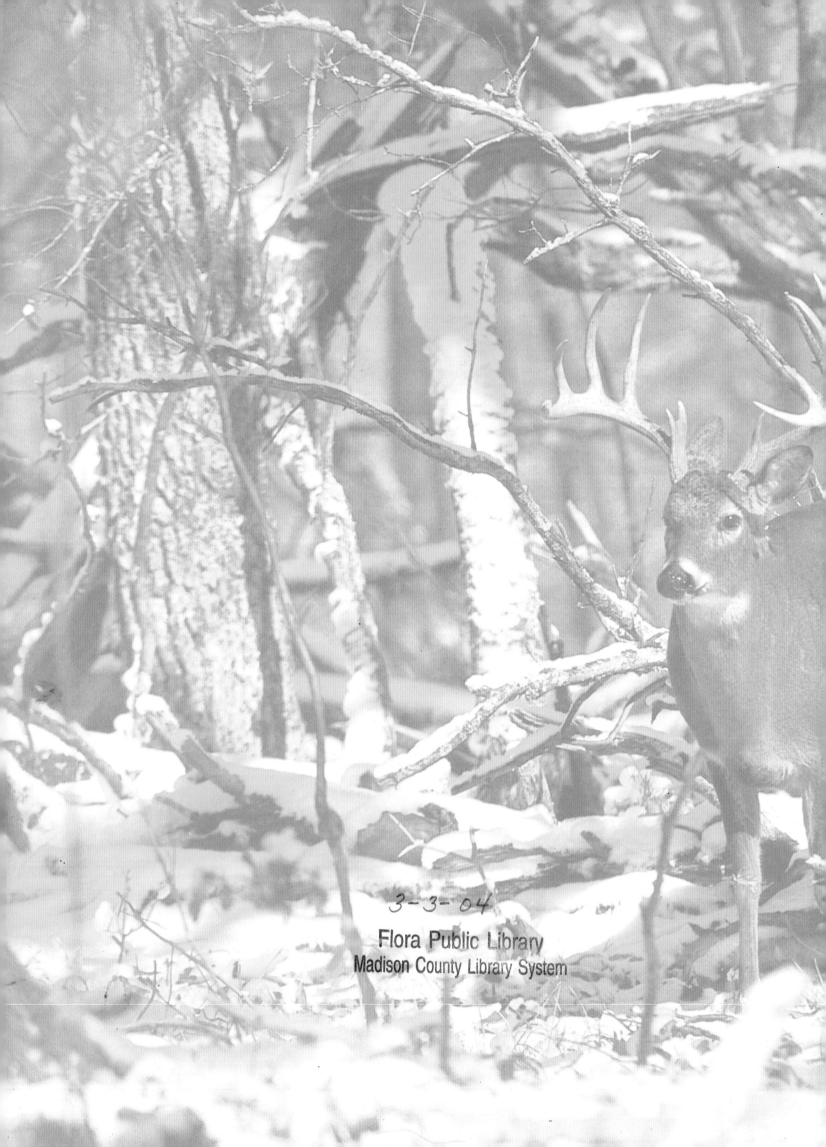

3-3-04

Flora Public Library
Madison County Library System